MERSEYSIDE WAR YEARS
THEN & NOW
IN COLOUR

DANIEL K. LONGMAN

COLOUR PHOTOGRAPHY BY TONY SHERRATT

The History Press

Dedicated to the victims of war.

Lest we forget.

First published in 2012

The History Press
The Mill, Brimscombe Port
Stroud, Gloucestershire, GL5 2QG
www.thehistorypress.co.uk

© Daniel K. Longman, 2012

British Library Cataloguing in Publication Data.
A catalogue record for this book is available from the British Library.

ISBN 978 0 7524 6352 0

Typesetting and origination by The History Press
Manufacturing managed by Jellyfish Print Solutions Ltd
Printed in India.

CONTENTS

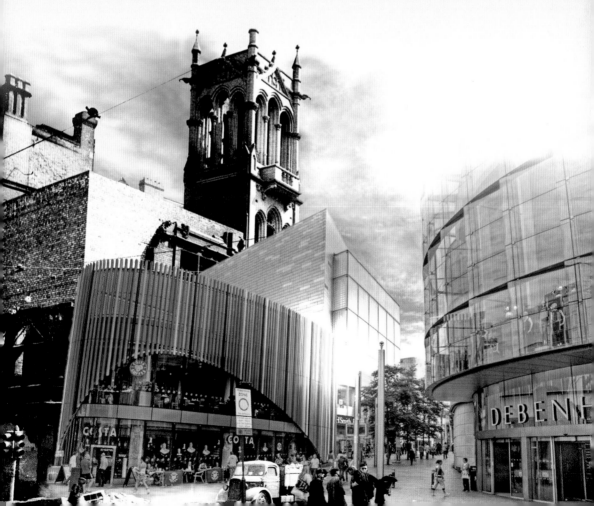

ACKNOWLEDGEMENTS

With thanks to:

Tony Sherratt
Pat and Mary Bennett
Eric Ray-Pugh
Birkenhead Central Library
Wallasey Central Library
Liverpool Record Office
The online communities of www.wikiwirral.co.uk, www.yoliverpool.com and
www.my-liverpool.proboards.com

ABOUT THE AUTHORS

Daniel K. Longman
Birkenhead-born Daniel has a passion for history and a keen interest in genealogy. He has written
a number of books to date, including *Liverpool Then & Now* and *Wirral Then & Now*. His avid
interest in exploring and uncovering Merseyside's criminal history has also seen him produce
the titles *Criminal Wirral*, *Criminal Wirral II* and *Criminal Liverpool*. Aged twenty-three, Daniel
completed an English degree at Liverpool John Moores University in 2012. (www.facebook.com/
DanielKLongman)

Tony Sherratt
Tony was born in Hull in 1956, but has lived in Merseyside from an early age. He has always had
a strong interest in art, entering and winning his first competition at the tender age of ten. It
was about that time that Tony acquired his first camera and, with it, a love of photography. Tony
studied Fine Art at Liverpool Polytechnic, graduating in 1979, and is now a teacher. He enjoys
travelling, documenting his journeys with photographs along the way. Check out his wonderful
online albums for some spectacular shots: www.flickr.com/photos/12547928@N07/

INTRODUCTION

My interest in the events of warfare began tentatively; the fields of the Western Front all seemed too distant, and the aged statistics on honour rolls seemed impersonal; bulky volumes of names, dates and old-fashioned maps from years gone by. I am too young to have experienced the trauma inflicted upon our nation, having grown up in relative modern comfort.

By undertaking the research for this book, I have been exposed to a fascinating period of our history that is slowly disappearing into the shadows of time. With each elder that passes, the authentic human memories of conflict – the pain, the anguish, the sorrow, the joy, the happiness and the relief – passes with them.

How I now wish I was able to talk with my late great-grandmother, Hilda McDonnell. She would surely have some tales to tell of life in wartime Wirral. She would, no doubt, describe the immense difficulties involved in bringing up a young family in the 1940s, in a small house in Rundle Street, all alone while her husband was fighting in France. She died when I was fourteen, and I didn't get to ask about her reminisces.

We should never forget the sacrifices given by our armed forces abroad, and we should never forget the bravery of those men and women who stayed behind at home, guarding our shores from potential invasion and raising families, not even knowing if they would survive to see a victory day.

The work for this book has highlighted some of the incredible experiences forced upon Merseyside, and I am proud to bring these memories to a new generation here in the twenty-first century. I hope these photographs, although unquestionably a poor substitute for real-life experience, serve as a reminder of how the events of war have shaped the Merseyside, and indeed the Britain, that we know today.

Daniel K. Longman, 2012

ORIEL CHAMBERS

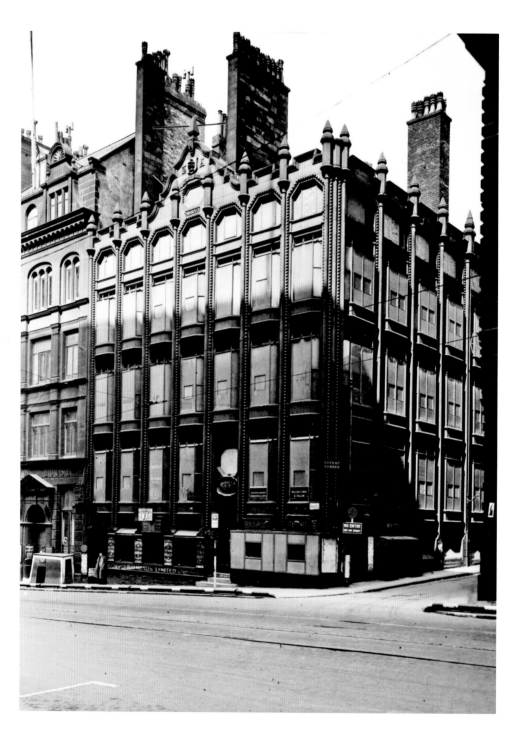

THE MAGNIFICENT ORIEL Chambers was built in 1864 by the pioneering Liverpool architect Peter Ellis. This building was the forerunner to the modern skyscraper, as it was built with a revolutionary cast-iron frame. Such ideas influenced many of the dominant twentieth-century constructions of America, including Chicago's Reliance Building. Ellis's thinking was way ahead of his time and it upset many in the architectural establishment. One disgruntled contemporary even described Oriel Chambers as 'a monstrous agglomeration of protruding plate glass bubbles'. Put off by this scathing criticism, Ellis designed only one other building in his lifetime: 16 Cook Street, in 1866. The large windows of Oriel Chambers were designed to allow in as much light as possible to illuminate each room; however, the image on the left, taken in 1942, appears to show them clad in some sort of protective sheeting. During the war, Oriel Chambers received acute bomb damage, which opened up the rear of the building, exposing the remarkable inner-metallic skeleton of Ellis's modernist creation. The destruction prompted renewed interest in the building; Ellis's foresight and architectural ingenuity was finally recognised across the world.

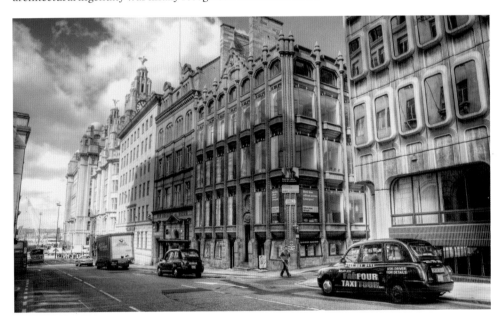

TODAY, ELLIS'S CREATION continues to play an important part in Water Street's exceptional aesthetic appeal. It was made a Grade I listed building in 1966. The previous year, a team of solicitors moved into Oriel Chambers to start a new practice. Today, over fifty barristers make up the company, which specialises in no less than seven distinct areas of the law. The five-storey building now also contains 43,000sq.ft of office space, thanks to the addition of a 1950s extension constructed to repair the bomb damage received a decade earlier. A recent purchase of the building cost a massive £5 million and it is now owned by the property firm Bruntwood. Their sign advertising available space can be seen in two of the large glass windows on the corner of Covent Garden, whilst in the basement, Copy Stop – a printing firm – occupies the lower rooms. Water Street continues to be a main route through the city, with many visitors travelling down it to reach the world-famous Liver Building, the Museum of Liverpool, and the ever-popular Albert Dock.

VICTORIA STREET

VICTORIA STREET IN 1941 (right). The General Post Office can be seen standing elegantly between Stanley Street and Sir Thomas Street. It was built in the 1890s by Sir Henry Tanner, in a luxurious, Italian Renaissance style, second only to the post office of St Martin's-le-Grand in London. Before its construction, the city's post was dealt with at the Customs House, which included the offices of the Mersey Docks and Harbour Board, and a telegraph office. The air raid of 3 May 1941 was one of the worst of the Second World War, with approximately 500 German bombers participating in a seven-hour bombardment over the district. This image shows the post office covered in scaffolding several months after the attack, which destroyed much of its interior. So bad was the damage that officials were forced to remove the remaining parts of three upper floors, which had been rendered unsafe by enemy action. These extra storeys can still be seen in this photograph and were adorned by decorative sculptures by the Victorian artist Edward O. Griffith; they are now, sadly, all lost.

THIS PHOTOGRAPH OF Victoria Street (left) shows the old post office in its considerably shorter guise. Along with the installation of a new roof, the innards of the old post office were finally refurbished in 2003 after decades of neglect. It is now home to the city's fashionable Met Quarter. The precinct features a selection of chic clothing stores and jewellery merchants, along with a small number of stylish cafés and boutiques. It was officially opened in 2006 after a costly development, and with almost forty stores, it is currently the third largest shopping centre in Liverpool. During its development, students from Liverpool John Moores University supplied their own artistic creations to the otherwise depressing boarding around the building site, which, in turn, created what was to be the area's largest outdoor art gallery. The Met Quarter served as a springboard development for Liverpool's much needed inner-city regeneration, and was a respectable forerunner to the celebrated Liverpool One shopping area.

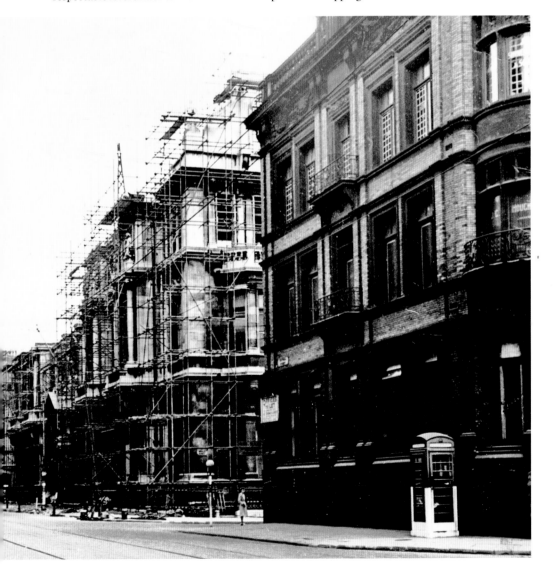

97 OXTON ROAD, BIRKENHEAD

IN BIRKENHEAD'S OXTON Road there once stood a pub known as the Victoria Vaults, the cavernous remains of which are shown below. On the evening of 12 March 1941, Wirral's residents were shaken, once again, by the eerie cry of an air-raid siren. Many ran for the cover of a public shelter or down into the basement of their own residences. The Savilles were one such family; they descended into their pub's underground barrel cellar and shut the hatch tight. Before long, the dreaded drone of aeroplane engines could be heard racing overhead, with waves

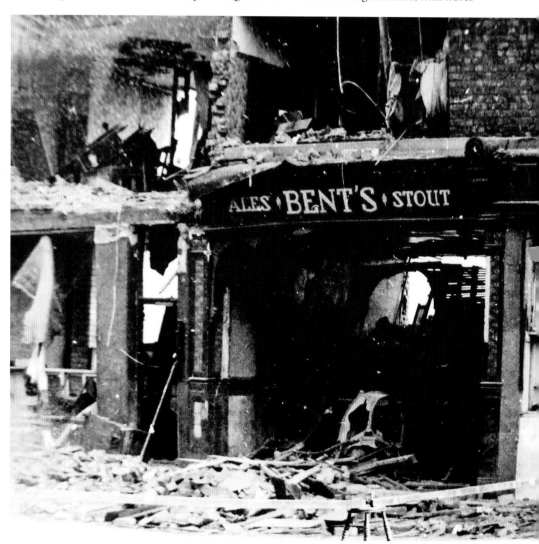

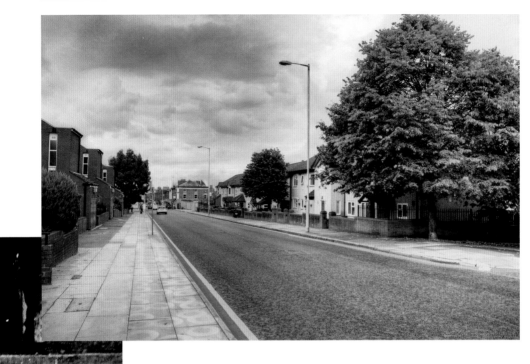

of anti-aircraft fire in hot pursuit. Suddenly, there was a loud crash and the family's electric light flickered off, leaving them in darkness. Shortly afterwards, the sound of wardens' voices permeated the commotion and the family called out frantically, shifting through what was increasingly becoming a death trap. Shaken but safe, the Savilles were ordered out of the cellar and ran to the house of a neighbour. Next door at No. 95, 51-year-old Lillian Robb, wife of chip shop owner George, was not so lucky. She had been sheltering in her own cellar when the ceiling collapsed above her, burying the poor woman in an instant.

A ROW OF residential houses occupy the site today, leaving no trace of the devastation that took place over seventy years ago. As well as the Victoria Vaults and chip shop, other pre-war properties have also disappeared. Thomas Griffiths' butcher's shop, the decorators Richard Green & Sons, the premises of John McKenna's timber merchants, Armistead's motor engineers, Edmund Brimmell's printing shop and the offices of the Birkenhead Brewery have all been replaced by this stretch of houses (above). This road leads to the pretty suburb of Oxton, but this leafy conurbation did not escape bombing either. In Holm Lane, in April 1941, houses suffered intense damage. These properties were more likely to come under attack as they were opposite an AA gun battery, rattling out bullets on a nightly basis. The Hermitage, in Ingestre Road, was blitzed the following month and the house was actually cut in two. The occupants had only moved in relatively recently but they escaped with their lives after fleeing to their shelter. Many other Oxton homes were lost in the raids. Nowhere was truly safe.

11

TITHEBARN STREET

THE REAR OF the majestic Town Hall can clearly be seen through the mangled destruction in this scene. Taken at the junction of Tithebarn Street and Old Hall Street, the rubble on what is known as Exchange Flags, one of the most crucial and strategic locations of the war effort, dominates the view. In 1941, the nation's central operations unit, Western Approaches, was transferred to Liverpool from Plymouth and based here in a secure bomb and gas-proof underground command centre. Deep below the war-torn streets, a multitude of naval and RAF personnel worked tirelessly in planning Britain's advancement against the tactics of the German generals and the U-boat menace. This hidden citadel covered 50,000sq.ft with approximately 100 rooms decked out with the latest in military technology

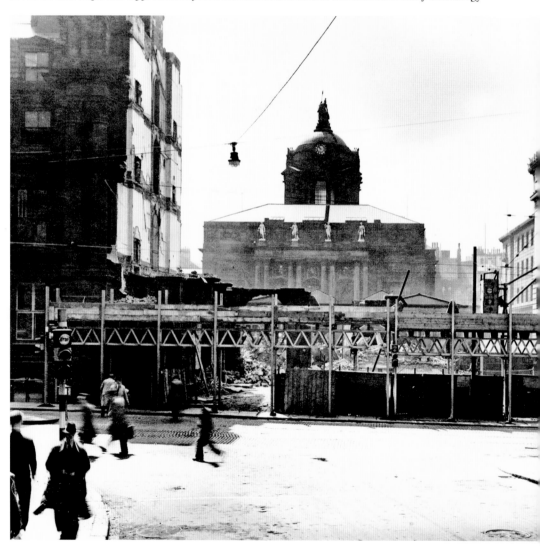

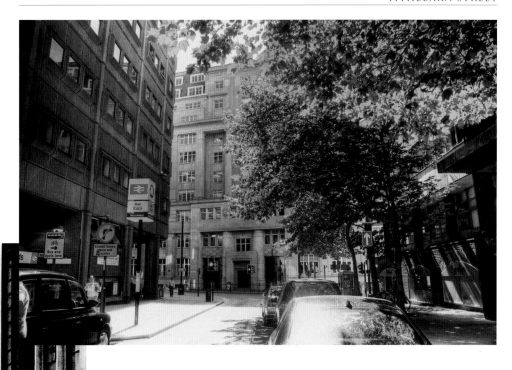

and equipment. These included map offices, plotting rooms, telecommunications stations and even a hotline connected directly to the War Cabinet in London. It was from here that the hunt for the German battleship *Bismarck* was strategically devised by the country's elite. At more than 50,000 tonnes, she was the largest warship of the day and posed a serious threat to British naval interests. On 27 May 1941, the fearsome *Bismarck* was successfully sunk in the Atlantic, much to the jubilation of the triumphant officers at Western Approaches.

THE TOWN HALL can no longer be seen since the completion of widespread repairs at Exchange Flags, but the secret underground command centre remains safely intact. Western Approaches has been sensitively restored to how it had been during the war, as a memorial to all those who perished in the conflict. Inside, genuine historical artefacts are available to view and study, as well as a reproduction of bombed-out quarters and even an imitation Anderson Shelter. The main attraction of the building is the map room. It has been renovated to create a 1940s atmosphere, with tactical charts adorning the walls and the all-important 'situation table' positioned in the centre of the room. The idea is that visitors feel they are stepping back in time as they descend into the very same rooms and corridors that were once occupied by Britain's most pre-eminent tacticians, nearly seventy years ago. To the left of the above photograph stands Moorfields Station. This was opened in 1977, soon after the closure of Exchange Station in nearby Tithebarn Street. It closed its doors for the final time after serving the area's commuters since 1850.

MANOR ROAD, WALLASEY

MANOR ROAD CLEARLY took some severe bombing, as proved by the condition of the houses in the picture below. Buildings to avoid the bombs included the exquisite Unitarian Memorial Chapel, complete with its octagonal turret, which can be seen further down the road. The chapel had been opened back in 1899 and was designed by Edmund Ware and Edmund Rathbon. It was furnished with an array of Art Nouveau fittings and was a rare example of the Arts and Crafts style in a nonconformist chapel. However, only yards away are Nos 54–58, which were all but obliterated in the winter of 1940. Mrs Elsie Denvir and Mr William Tyers died at No. 54; a total of four members

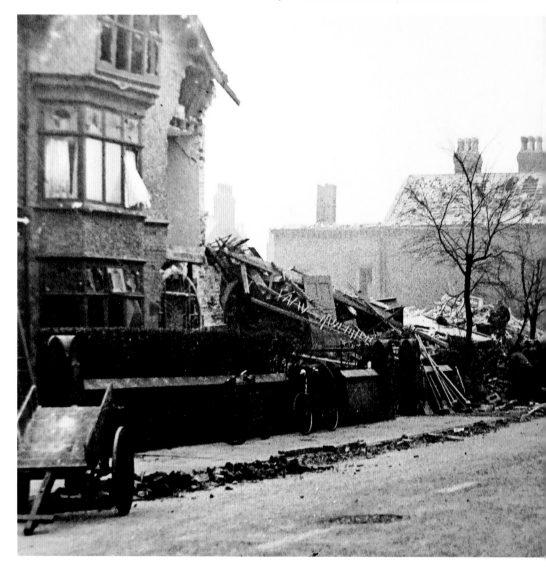

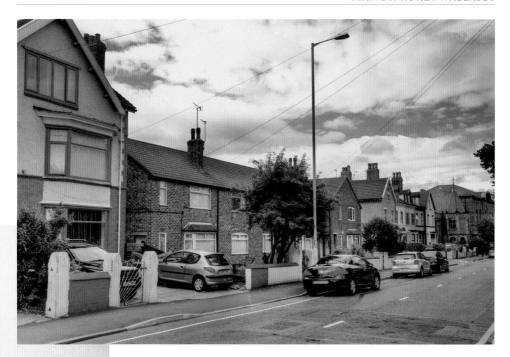

of the Brayshaw family died at No. 56; and Mr Alexander Ramsay, and widow Janet Potter died at No. 58. Further causalities occurred when the Rogers Home for Elderly Ladies took a direct hit at its location on the corner of Withen's Lane. There were thirteen recorded victims; some were gassed to death beneath the rubble as gas pipes ruptured. Wardens worked throughout the night and first-aid parties continued to assist all those in need, ignoring threats to their own personal safety.

THE BLITZED HOUSES of Manor Road were cleared away and today a series of relatively recent residences feature in this row of fine Victorian houses. These were just some of the 18,000 houses damaged in Wallasey over the course of the Blitz. The attractive Unitarian Memorial Chapel has survived at its location near to the junction of Grosvenor Street, and retains its Grade II listed Art Nouveau splendour. The Wallasey Ballet School makes use of the chapel's facilities, which have been repaired and upgraded over the years. It is also used for conferences, meetings and exhibitions. The imposing redbrick block that is the Wallasey Concert Hall is also visible. This was constructed in 1875 and financed by local entrepreneur James Brewin. The hall would later play a pivotal role in the upkeep of people's spirits, with wartime dances and community parties regularly held to boost morale. The hall managed to survive the multitude of mines that parachuted down on Merseyside, especially in Wallasey, and it is still in use today as the Grosvenor Assembly Rooms and the 27 Social Club.

BOLD STREET

SEEN HERE AT the top of Bold Street is the head office of Liverpool Savings Bank. Branch buildings were at one time a familiar sight across the city, which was home to a number of other banking institutions such as Martins, Heywood's and Craven. The building was originally used by freemasons as a meeting hall, before being taken over by LSB in the mid-nineteenth century.

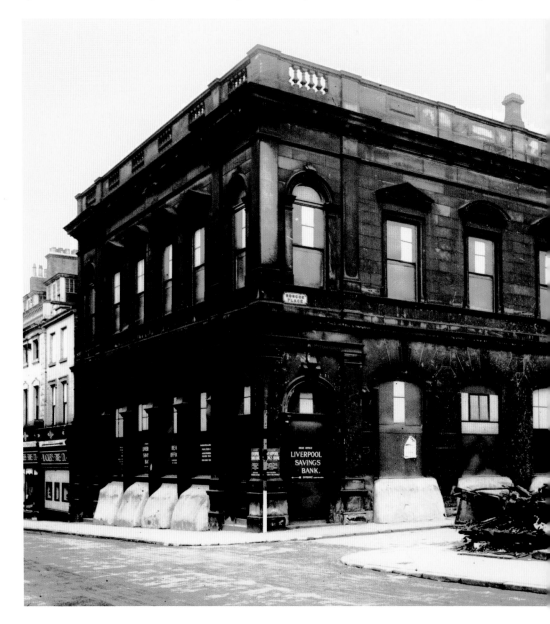

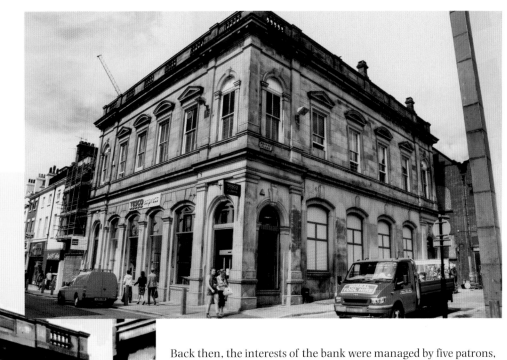

Back then, the interests of the bank were managed by five patrons, five trustees and twenty-one committee members. The rubble lying next to the bank is due to the Blitz and was previously the property of Allen & Appleyard, a team of house furnishers dating back to 1879. The firm had conducted business from premises in Renshaw Street and boasted a reputable name in the city's furniture trade. Just to the edge of this image are signs for the Midland Bank Limited and the Co-operative Insurance Society, and in the far distance stands a Blacklers Store, advertising trunks, prams and toys to the general public.

THE RETAIL GIANT Tesco now occupies the old bank premises. This was Liverpool's seventh Tesco store, and on opening in 2009 it added to the already thriving monopoly of the publicly divisive supermarket chain. The former CEO of the company, Sir Terry Leahy, originally hails from the Belle Vale area of Liverpool, and for his business achievements was presented the Freedom of the City in 2002. To the edge of shot, across Roscoe Place, now stands Andrew Collinge Graduates. It is one of two such hairdressing establishments on Merseyside, the other being located on Milton Pavement in Birkenhead town centre. The Blacklers store, which formerly stood next door to the Liverpool Savings Bank, has long left the street and the building has now been divided into two. Bold Street Coffee is based in one half, whilst the other currently stands unoccupied.

WILLIAM BROWN STREET

A MAN CAN be seen here walking up William Brown Street; he is about to pass one of a number of air-raid shelters erected about the city. To the left of him stands the magnificent museum and library, built in 1860. The cost of the creation exceeded all expectations, prompting local merchant and MP William Brown to personally donate £41,000 of his own funds to finish the mammoth project. His benevolence led to the street being rechristened in his honour (it was formerly Shaws Brow). Hitler's expansion ambitions, eighty years after the grand museum's opening, forced staff to hide the building's most valuable and prized artefacts away, for fear of bomb damage, but by the time this picture was taken in the 1940s, the building had indeed

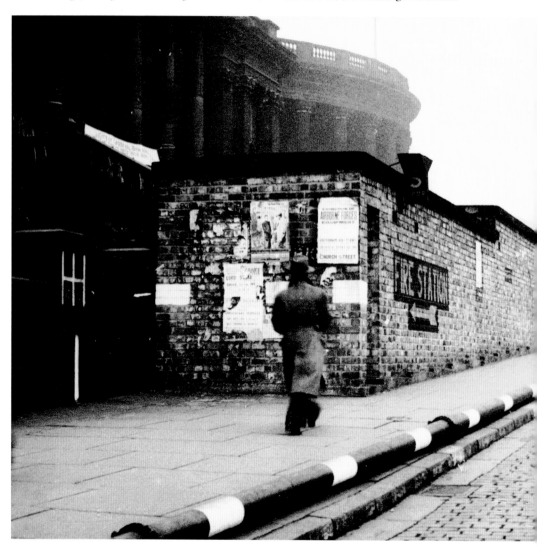

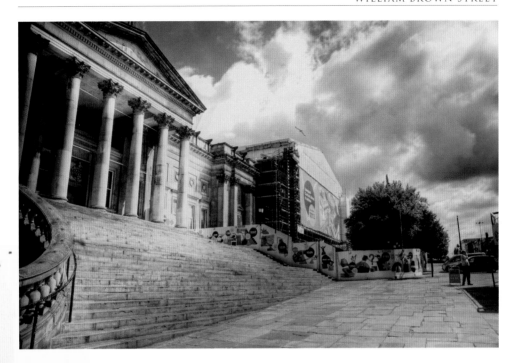

fallen victim to an enemy attack. Extensive damage was suffered during an early morning air raid and much of the museum's Egyptian exhibitions were destroyed forever. In the distance stands Wellington Column, commemorating the Napoleonic achievements of the Duke Wellington. It was built in 1865 and cast from the metal of French cannons captured at Waterloo. This bold and striking 40m-high pillar survived the war unscathed.

WILLIAM BROWN STREET remains one of the most cultural parts of Merseyside and is a magnet for tourists who come to visit the Liverpool World Museum and its neighbour, the Walker Art Gallery. The old air-raid shelter no longer stands, leaving a large and spacious pedestrian area at the base of the museum's palatial stone steps. Vibrant hoardings have been erected in an attempt to hide the building work taking place at the Central Library and Archives further up the road. In summer 2010, the library closed its doors to begin a £50 million transformation, which planners estimate will take approximately two years to finish. By then, the 160-year-old building will have totally changed and will be filled with state-of-the-art technology, designed with public accessibility in mind. The mid-twentieth-century additions to the library are currently in the process of being demolished, whilst the original Grade II listed portions are soon to be restored to their former glory. Until then, history enthusiasts are forced to consult local records at a temporary warehouse near Great Howard Street, but for book-lovers, a short stroll to the World Museum will lead them to a small, provisional library based on the second floor.

THE DERBY BATHS,
NEW BRIGHTON

THE NORMALLY HAPPY leisure spot that was the Derby Baths in New Brighton shows yet more evidence of the desolation and sadness the Second World War brought to our shores. The Derby Baths opened seven years before the outbreak of hostilities and at that time a visit to the pool was an all-round family favourite. It had been opened by its namesake Lord Derby in Harrison Drive, on 8 June 1932, after £35,000 worth of construction. It was estimated that up to 1,000 bathers could take a dip at any one time, while another 2,000 could laze around at the poolside. The pool itself was 100 yards long and had depth of 7ft. The surrounding Derby Baths' buildings are depicted here after bombing in 1940. Liverpudlian Louis Freeman died at a shelter based in

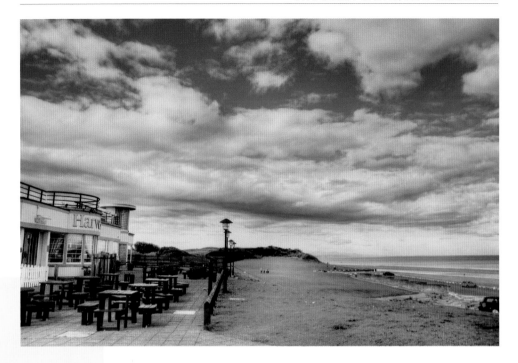

Harrison Drive in December of that year, and Margaret Rogers of Danehurst Road was also fatally injured, dying from her wounds two days later in Leasowe Hospital. Further along the promenade, past the Derby Baths, the authorities had set up a minefield in the sand dunes for fear of invasion. Regrettably, the only fatalities were to four young lads who had ventured onto the dunes, not realising what a terrible threat lay buried beneath the sand.

THIS VIBRANT VIEW of the site (above) shows that the pool is, sadly, no more; a pub (with restaurant) stands at the location now. It is owned by the nationwide Harvester chain and is just off Harrison Drive at a new address called Bay View Drive. Naturally, it boasts some beautiful views across the bay and can be found packed with families on sunny afternoons. The pool site itself has been filled in and now a vast expanse of grassland helps create this pretty seaside vista. The restaurant takes its name – The Derby Pool – from the scene's aquatic past. It was only built in the late 1990s but has an Art-Deco style. The development team, Neptune, currently working on several multimillion pound projects in New Brighton, with a new supermarket, a Travelodge hotel, a digital cinema, bars, restaurants and much more soon to be kick-starting the resort's renaissance. Their plans also feature a brand new public pool, reminiscent of the Derby Baths and its sister, the New Brighton open-air baths. The latter had been considered to be the largest outdoor swimming pool in Europe but in 1990, this too was demolished after serious damage from a storm.

ST LUKE'S CHURCH

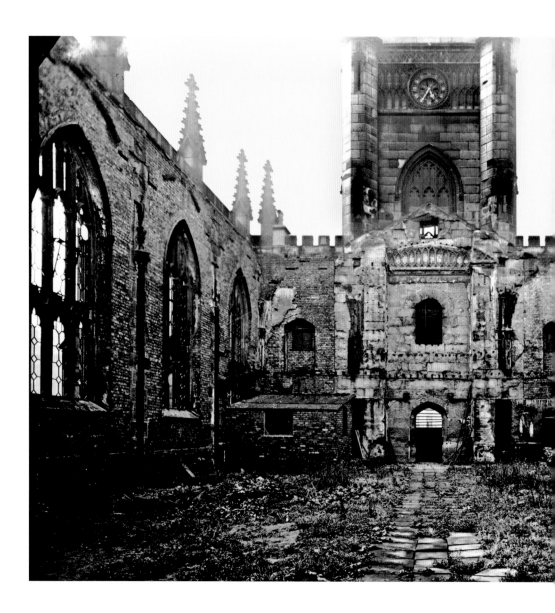

THIS 1950s SHOT shows the ruined interior of St Luke's Church as it stands at the junction of
Leece Street and Berry Street. Work on the church had originally started way back in 1802 from
the designs of John Foster, one of Liverpool's most prolific architects. His son would later oversee
the completion of the project in 1831, when the wonderfully gothic structure opened its doors for
the first time. Over a century later, on the night of 6 May 1941, an incendiary device was dropped
through the roof of the church, causing a truly catastrophic fire that raged throughout the

building, leaving nothing more than a burnt-out shell. The rows of wooden pews caught alight immediately and almost every one of the historic stained-glass windows shattered into thousands of fragments. The elevated church bells also met a fiery end, as five of the eight hanging in the belfry crashed to the ground; the remaining three cracked under the intense heat of the flames. Amazingly, the cast-iron bell frame survived the blaze; this was the first such frame in the world.

ST LUKE'S CHURCH remains a testament to Merseyside's stalwart resilience to enemy aggression. It has become known affectionately as the 'bombed-out church'. St Luke's no longer conducts regular religious services but instead operates as a unique setting for art events. An assembly of creatives – Urban Strawberry Lunch – currently work as artists-in-residence at the church and for a number of years have organised a range of different events: poetry nights, film showings, and photography exhibitions have all been enjoyed here. St Luke's has become an attraction in its own right and received over 80,000 visitors in the period 2006–2010. Outside, the tranquil gardens offer a place of harmony for busy city dwellers to sit and watch the world go by. The gardens also contain a stone tribute to the victims of the Irish famine of 1845–52. It is the only such monument in England. In July 2010, Martin Lowe and his fiancée, Amanda LaRagione, successfully sought permission to hold their marriage service in St Luke's, making them the first couple to marry there since the outbreak of war.

ST JOHN'S FISH MARKET

ON 21 DECEMBER 1940, over 100 bombers made their way over Merseyside to begin a truly shocking wave of airborne destruction. A flying armoury of parachute mines, explosive bombs and incendiary bombs rained down upon the streets below, mercilessly destroying everything they hit. One such location was Roe Street and the historic fish market. Over the years, fish markets had been located in Chapel Street, before moving to Pool Lane, Derby Square and then moving again across to James Street. In 1887, the city's fish trade rocketed and it was recorded that an enormous 25,000 tons passed through its stalls. This put a great strain on the seriously inadequate trading conditions, so at a cost of £18,000, a new market was opened. Trading commenced in 1889 and stalls were stocked high with all manner of sea-food fished from local shores and further afield. It was conveniently located in close proximity to the older St John's Market, and both served as popular shopping destinations for decades. All this was brought to a brutal end when the fish market was annihilated during those cold winter hours in 1940.

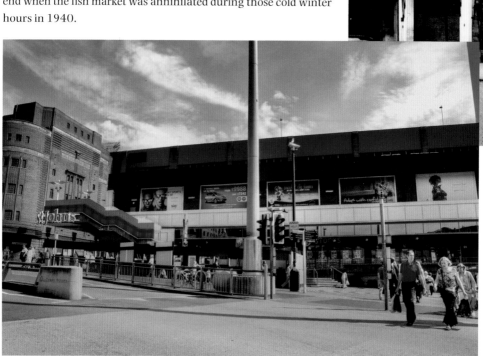

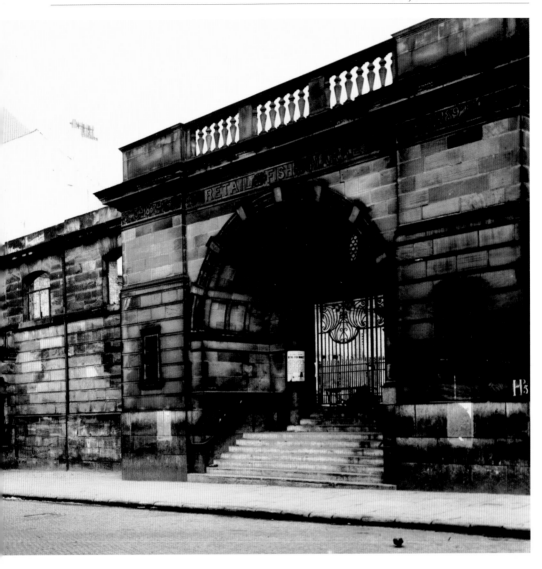

THE FISH MARKET, as well as the whole of Rose Street, has been replaced by the sweeping glass construction that is St John's Market. However, this is not the original market, but one that was opened by Queen Elizabeth II in 1971. The previous decade's councillors agreed that the old markets (which had by this time fallen into a state of dangerous disrepair), needed to be modernised and rebuilt. Both the fish market and St John's market were demolished and developers worked on constructing the building we see today. In this image on the left, the outdoor steps leading up to the first floor are being altered to create a more pedestrian-friendly means of access for shoppers, but the inside has become a little dated. In 2008, reports appeared in the local press regarding designs for a brand new, multi-million pound upgrade to the properties on this site. These proposals suggested that the two storeys of the market would be vastly improved with natural lighting throughout, and the addition of a new food terrace overlooking Clayton Square. At the time of writing, this has yet to be implemented.

THE CUSTOM HOUSE

THIS SORRY VISTA (below) shows the once splendid Liverpool Custom House after it had suffered atrocious damage at the hands of the Nazi air force. It had originally been built to the designs of John Foster in 1839, replacing several older offices that were proving inadequate for the city's ever-expanding shipping interests. It housed the excise offices (which were located to the west of the building), as well as a post office situated in the eastern section, a telegraph office and later, the offices for the Mersey Docks and Harbour Board. One Victorian visitor was so taken with the construction, he urged fellow tourists to spend an hour just admiring the splendour of the Custom House, which he believed to be a beautiful and lasting ornament to the then second city of the Empire. The bombing it received on the night of 3 May 1941 left this cherished gem a mere shadow of its former greatness, with the inside completely gutted beyond repair. The overall structure

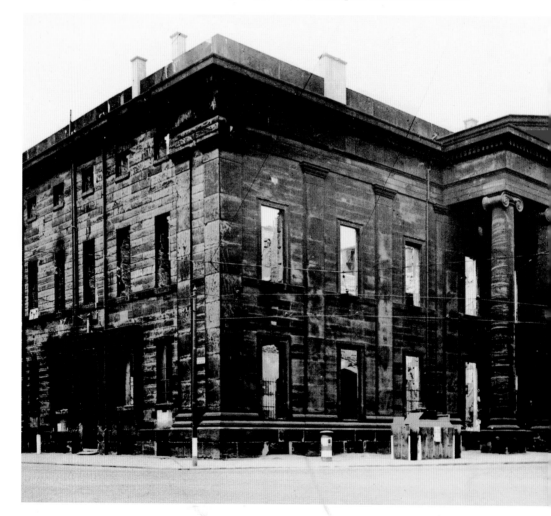

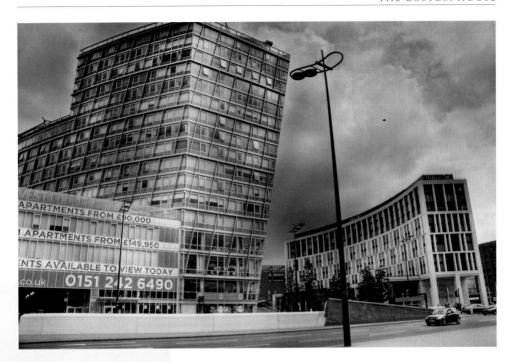

itself, however, was surprisingly resilient and stood as a powerful testament to its well-built and architecturally robust design.

ONE OF THE nation's worst acts of civic vandalism occurred when city planners agreed to tear down the remains of the blitzed-out Custom House. Despite its dreadful interior damage, the property's walls remained perfectly useable, but this fact meant nothing to local officials who, in 1948, razed this historic building to the ground. The site is now partly occupied by the Paradise Street bus station, which was constructed in 2005. Along with Queen Square and Sir Thomas Street, its ten stops enable buses to transport people to and from all parts of Merseyside. It is wedged between the headquarters of Merseyside Police and the newly-built Hilton Hotel. These are located in an area of the city centre known as Chavasee Park, which is overlooked by the distinctive flagship development of One Park West. This was designed by the architect Cesar Pelli, whose most famous work is the Petronas Towers in Kuala Lumpur. At seventeen storeys, One Park West contains over 300 high-class apartments with many boasting excellent views across the Mersey. During its construction in 2008, a time capsule, which included some of the first sketches of the building's design, was buried deep within the foundations for future generations to one day discover.

LATHOM AVENUE, WALLASEY

A TEAM OF ARP (Air Raid Precaution) men, complete with Brodie helmets, pose outside a blitzed house in Lathom Avenue, Wallasey. There were over a million such ARP workers across the country, with most dedicating their spare time, without pay, in an effort to keep the streets as safe as possible. In this instance their job was to make the bombed-out house as safe as possible, and conduct a search for any survivors that may have been trapped within. This picture shows how the front wall has been blown out across the street along with the gate and parts of the windows.

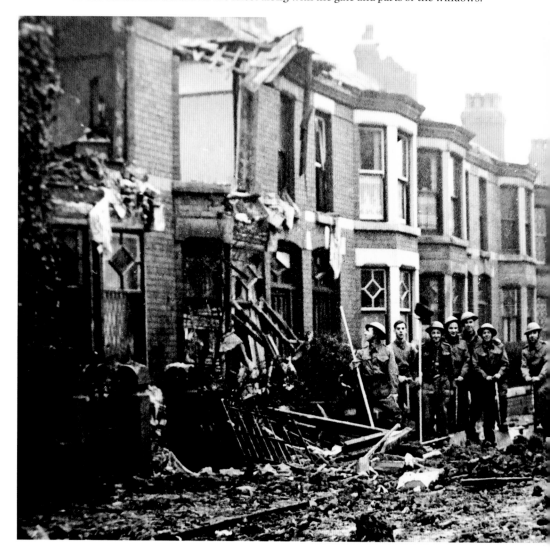

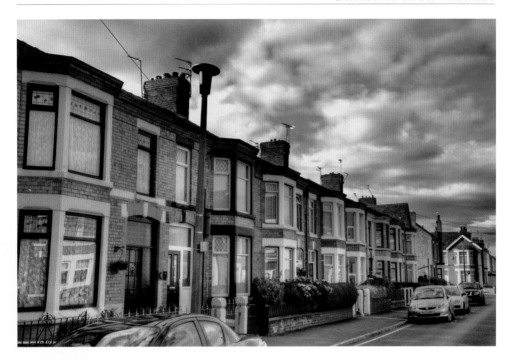

Several other houses in the street have suffered similar damage but this does not appear to have dampened the warden's spirits, who each seem happy to stand for the photographer. The road alongside here was Mill Lane, and it was there, on 12 March 1941, that the Isolation Hospital received a direct hit. This attack wiped out Ward 2, the male diphtheria unit, and it was the sad duty of nurses to break the news that two young patients, 4-year-old John Bellamy and 9-year-old John Byrne, had both been both killed in the blast.

THE HOUSES IN this street appear in surprisingly good condition today; it seems hard to imagine that war ever impacted this area. Not far from this scene, one of the most miraculous events of the period occurred. Houses on Lancaster Avenue had been destroyed along with an air-raid shelter, and consequently death came to many. The debris was piled high and it was with great determination that wardens waded through, but they had little hope for survivors. After three days of searching, an incredible rescue – one against all the odds – took place on Sunday, 16 March 1941. Faint cries could be heard under the mass of bricks and, at first, the rescue party expected to find a frightened feline. Rescuers carefully began to shift the layers of debris and were amazed to find a baby girl! With great care, they dug her out and found that she was on the brink of becoming another of the war's youngest fatalities. First aid was given without delay and the infant was rushed to hospital. Wardens later revealed that the girl had only survived because she had been shielded by the bodies of her deceased parents.

WHETSTONE LANE, BIRKENHEAD

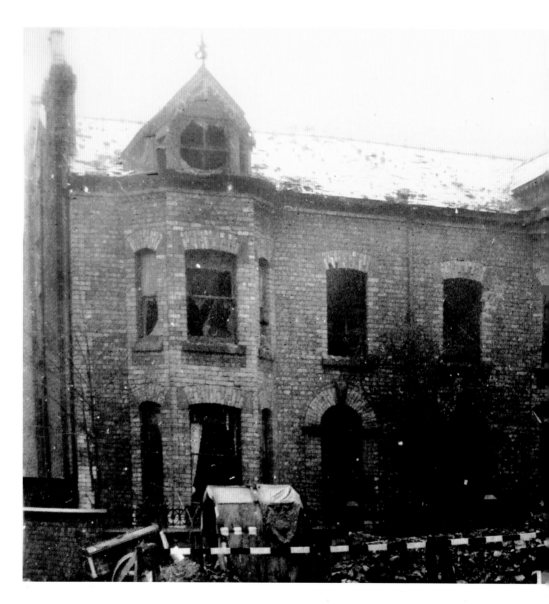

AT THE CORNER of Whetstone Lane and The Woodlands stand two large houses which have been rendered entirely uninhabitable. The glass of every window has been left shattered and parts of the brickwork have become dangerously unstable. Outside, officials have erected a barrier to seal off the property from the public, and the road and pavement is shown to be undergoing some

seriously needed maintenance. After the town of Bootle, Birkenhead suffered the worst number of casualties in Merseyside; almost 80 per cent of houses here were either damaged or destroyed. To raise Merseyside's spirits, Prime Minister Winston Churchill paid a surprise visit to the area in April 1941. He was met by Mayor Short in Duke Street, and driven around the neighbourhood in an open-topped car. To communal cheers, Churchill witnessed firsthand the devastation of Birkenhead and met with locals across the district. During the Second World War alone, the shipyard produced nearly 200 vessels – both commercial and military – in support of the war effort. These Included HMS *Rodney*, HMS *Prince of Wales* and the famous HMS *Ark Royal*.

A LENGTHY RESTORATION project has renovated these two properties back to a flawless condition; now only history holds proof of the ruination they once sustained. Just as they did during the war, the dwellings continue to stand in the shadow of the YMCA. The original Birkenhead YMCA was founded in 1874 and was located in Argyle Street, moving later to Grange Road in the town centre. It was there, in 1906, that Lord Baden Powell visited Merseyside and officially inaugurated the Boy Scout Movement. In the 1930s, the firm Lloyd & Cross was commissioned to build a new home for the charity. It was opened by the Earl of Shrewsbury here in Whetstone Lane on 4 February 1938. Many of the refugees who had been bombed out of their homes were accommodated in the building's sleeping quarters, as well as the many crew members brought in to work on vessels at Cammell Laird's shipyard. In 2006, the building was torn down and rebuilt; this was opened by the Duke of Kent in the summer of 2007.

BRUNSWICK STREET

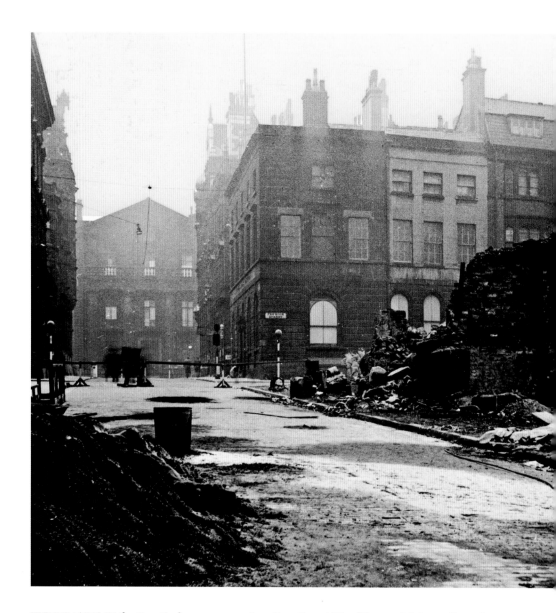

THE REMAINS OF the Corn Exchange are seen here from the middle of Brunswick Street, littered with the wreckage of war. On looking up the road, the Liverpool branch of the Bank of England can be seen over in Castle Street. This was once one of the grandest buildings the city had to offer and was built through a splendid combination of Greek, Roman and Renaissance styles. It was one of three commissioned in the 1840s to the designs of leading architect Charles Cockerell. He later returned to Merseyside to design another spectacular building, Dale Street's Liverpool and London Insurance

Office, and the interior of St George's Hall; the latter was an unexpected commission due to the death of the previous architect, Harvey Lonsdale Elmes. The soot-ridden building in the centre of this image is the Heywood's branch of Martins Bank, which appears to have had its ground-floor windows destroyed. Next door stands the premises of George Bennett & Sons, and John Elliot & Co., both of which operated as spirit merchants. In the upper rooms were merchants in the corn, grain and flour professions, as well as a firm of shipping agents and engineers.

WITH THE THREAT of attack finally over, the Corn Exchange was rebuilt in the 1950s and is now used as office space right in the heart of Merseyside's blossoming business district. The Bank of England building survived the air raids that rained down only yards away, and it remains in excellent condition, looking as grand as ever. It currently sits unoccupied but will no doubt prove a decidedly decorous address for any chief executive. The trendy Noble House stands to the right of this picture, whilst next door is The Chair, a small barber shop based in a basement workshop previously used as a tailor's shop. Over the road is the Restaurant Bar & Grill, located in the former banking hall of Halifax House. Inside, a striking cocktail bar takes centre stage and is flanked by plush dining areas. This neighbours Viva Brazil, a restaurant also based in an old banking establishment. The Brazilian-themed steakhouse opened in 2010, its developers paying particular attention to preserve the property's original features, whilst also bringing a friendly, South American atmosphere to the people of Merseyside.

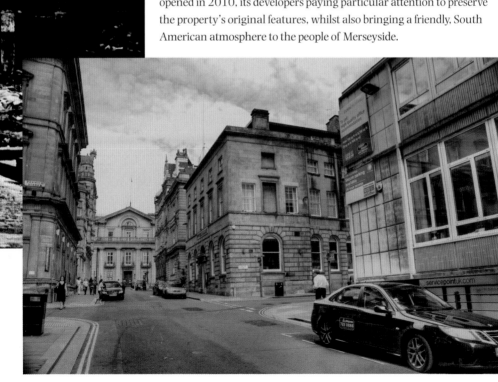

ST CATHERINE'S CHURCH

ST CATHERINE'S CHURCH once stood in the elegant grounds of the city's much-loved Abercromby Square. Named after General Sir Ralph Abercromby, the spacious properties of the square appealed to Georgian Liverpool's most well-to-do; many of its inhabitants were successful members of merchant professions. St Catherine's Church was later built on the eastern side of this leafy plaza, to ease the increasing pressure on the popular St Peter's Church based in the city centre. With plans drawn up by John Foster, the foundation stone for this new church was formally laid in 1829. St Catherine's was designed in a classical Greek style at a cost of £10,000 and with enough seating

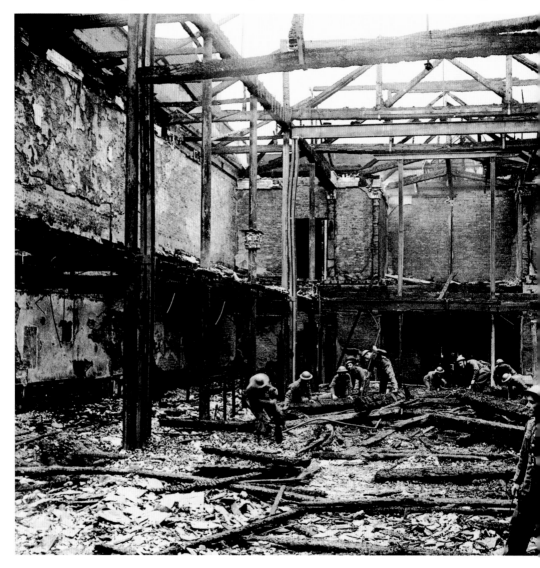

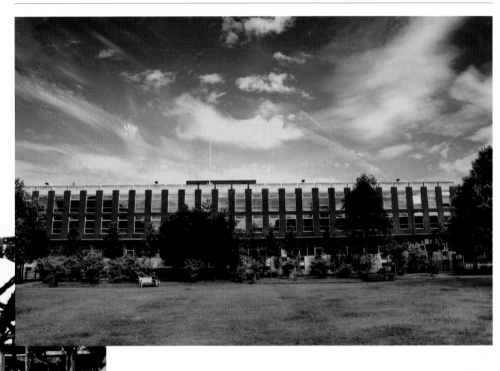

for 1,500 worshippers. Upon its completion, the building was consecrated in 1831 by the Bishop of Chester, John Bird Sumner, who rose to become the Archbishop of Canterbury. St Catherine's was blitzed in May 1941, causing the absolute devastation shown in this image (left). Wardens can be seen shifting through the rubble of this once revered building, as wrecked roof beams and piles of assorted masonry lay strewn across the floor.

IN THEIR EFFORTS for educational expansion, Liverpool University took over a number of the large properties in Abercromby Square and turned them into teaching and lecture rooms. This included the shell of St Catherine's Church, which the university acquired in 1966 and subsequently demolished. In its place stands the Sydney Jones Library, which houses the institution's main collections for the Arts and Social Sciences. Designed by Sir Basil Spence in 1976, the library was named after the four-time Lord Mayor of Liverpool and shipping mogul Sir Charles Sydney Jones. The wealthy businessman was a champion of learning and donated many properties on the east side of the square, and bequeathed what was to become the Vice Chancellor's official residence in Prince's Park. The library recently benefited from £17 million of investment, which extended it into the university's former HQ of Senate House and greatly updated its internal educational facilities. It now has space for more than 1.2 million books, new teaching rooms and a café with an outdoor terrace. The Sydney Jones Library was officially opened by Liverpool poets and honorary graduates Roger McGough and Brian Patten in November 2008.

35

THE GOREE PIAZZAS

THE GOREE PIAZZAS were an impressive pair of large and spacious eighteenth-century warehouses, constructed very near to the Liverpool waterfront. They were used to store the vast quantities of tropical goods brought back by seafaring merchants from all over the world. They were named after the African island of Goree, situated off the coast of Senegal, which was a small trading port in colonial times. Fire damage forced the piazzas to be rebuilt in 1802, and this image depicts the beginning of their ultimate wartime demise in 1941. The striking frontage of one warehouse can be seen centrally in this scene, and was known as Washington Buildings. This once housed the office of the celebrated American author Washington Irving, who had moved to Liverpool in 1815 to assist

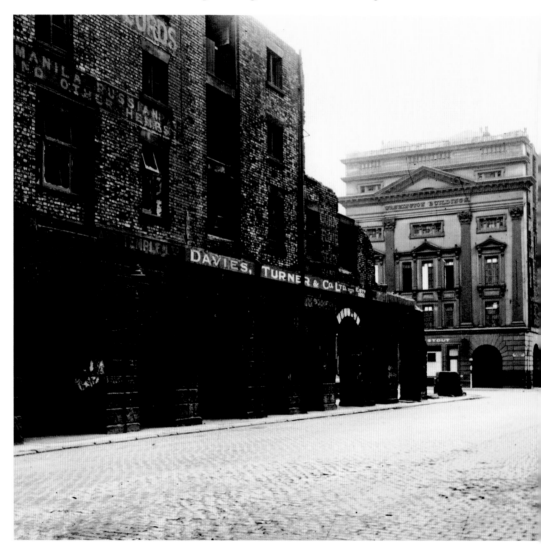

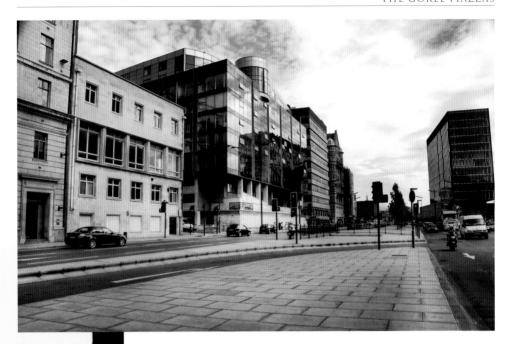

with his brother's merchant ventures. His view of the piazzas was less than complimentary; he described them as 'a shabby and smoke-stained edifice of four storeys at the lower corner of Brunswick Street'. In the distance is part of the overhead railway that once ran the length of the city from Seaforth to the Herculaneum Dock. It was the first such railway in the world and managed to survive the Blitz, albeit after extensive repairs.

AS THE PREVIOUS image shows, these huge warehouses were damaged during the war and in 1958 it was decided that these blocks should be brought down and finally demolished. This area of Liverpool is known as the Strand, so-called due to the Mersey waters that used to wash over here, and has been significantly widened to make way for several lanes of extremely busy inner-city traffic. The overhead railway (known as the 'Dockers' Umbrella' or the 'Ovee') was negatively affected by an assortment of social advances. The rise of the telephone resulted in fewer passengers using the railway to conduct business face-to-face, and the motor car was becoming an increasingly common sight on Merseyside's roads. For those without private transport, fares on the city's ample tram system were still cheaper and its carriages reached places the railway could not. In 1948, the British Railway was nationalised, but this did not include the Dockers' Umbrella due to it being a purely local venture. The tracks continued to fall into disrepair and extensive corrosion ate into its iron workings. The costs of repair work ran into the millions and by 1956, it was confirmed that the overhead railway would be dismantled.

DIOCESAN
CHURCH HOUSE

LIVERPOOL'S BEAUTIFULLY GOTHIC Diocesan Church House was situated in South John Street, housing the offices of the local diocese and its associated records and literature. The building replaced an earlier structure known as Clarendon Buildings and covered a plot of over 1,000 square yards. On the afternoon of 1 August 1899, the foundation stone was laid by the Countess of Derby, who formally declared the commencement of this new and ambitious project. It was to feature a hall with enough seating for 400 people, a diocesan registry, bishop's quarters, committee

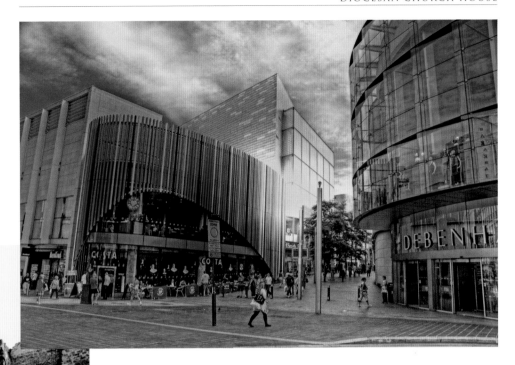

rooms, finance offices and even a library and reading room. Officials (particularly Bishop Ryle, who spearheaded the project) felt that Church House would be a superb addition to society, promoting widespread unity by establishing a common centre where the clergy and laity of the diocese could meet together. It is shown here in 1941, after a vicious air raid the previous year. Repair work can clearly be seen on the front portion of the construction, where there was once an elaborate, pillared tower. The lower rooms of the premises were totally destroyed.

AFTER THE WAR, Diocesan Church House was demolished and replaced by a rather bland and lacklustre office block. It wasn't until the twenty-first century that South John Street underwent a complete makeover, when Lord Grosvenor's development company invested £500 million towards the costs of the construction of Liverpool One, Britain's largest open-air shopping complex. Now the site is taken up by a very colourful branch of Costa Coffee, with its vertical rainbow tubes creating a truly self-assured optical statement. Critics have applauded the design, commending its unique combination of art and architecture. To the right is Debenhams, which opened in Liverpool's Capital of Culture year, 2008. As shoppers stroll further into the complex, they find that space in South John Street has been cleverly adapted using the very best in modern planning; the thoroughfare has been transformed into a two-tier street. Rows of stores, including the clothing shop Hollister, a branch of NatWest, a Lego store, Sports Direct, an Odeon cinema and many more besides, are all linked by a series of lifts and escalators.

JAMES STREET

THE REMAINS OF James Street Station lie in ruins to the left of this 1940s view. The station had first opened in 1886, after many hours of construction. The mammoth task of removing a mass of solid rock occupying what was to be platform level was a particularly testing job. Due to its inner-city location, planners included access to the station from nearby Water Street, for the convenience of merchants from the busy Exchange and other well-to-do businesses. As well as a refreshment room and ticket office, the station itself featured a trio of hydraulic lifts with mechanisms set high within a lofty tower overlooking the river and business district. These spacious elevators could accommodate up to 100 passengers; perfect for the busy rush hour. James Street station suffered heavy bombing and an abysmal amount of damage. Its neighbour, the 1920s American-style National Bank, was lucky enough to survive the Blitz and can be seen standing in the distance.

THE STATION WAS quickly rebuilt in 1942 and remained in situ for thirty years. It wasn't until the 1970s that James Street underwent a major facelift and a new single-track known as the Loop was installed to its system. This new addition allowed Wirral trains connected to James Street to also access Moorfields, Lime Street and Liverpool Central, and return back under the Mersey with ease. The silver station frontage seen in this image is only several years old, after a programme of refurbishment was put into action in 2008. A new booking hall, improved paving and upgraded bus stops all

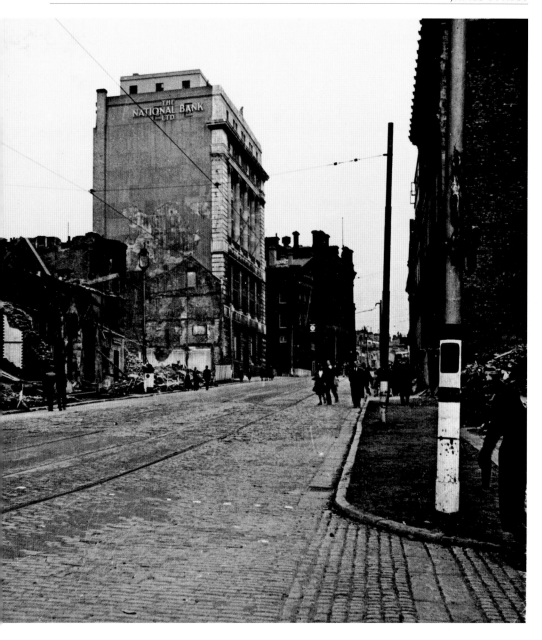

featured in Merseytravel's £1.5 million plan, which also included great improvements to Hoylake
Station on the Wirral. The Days Inn Hotel group have recently established themselves in James Street
and provide over 150 rooms to Merseyside visitors in this prime central location. Up ahead, the
National Bank has evolved into a trendy wine bar, simply known as The National. Its interior has been
largely preserved, giving the pub the affluent ambience that would have once been found in many
banks of this period. The rooms above have been converted into private accommodation, with many
enjoying some rather impressive views across Liverpool's business district, the river and beyond.

BOROUGH ROAD,
WALLASEY

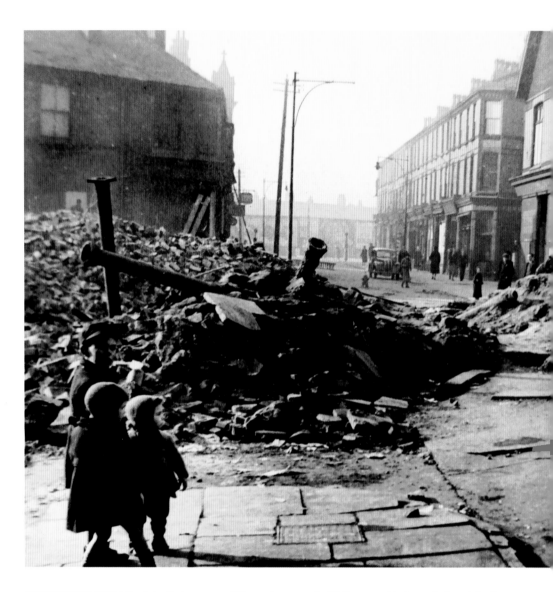

BOROUGH ROAD HAD originally been one of the main streets in Wallasey and in its early days it had been known as Victoria Road. However, in 1918, the name was changed to avoid confusion with one of New Brighton's most popular tourist hotspots that had the same name. Twenty years later, this street would witness a number of major fires, when approximately 100 kilos worth of electron magnesium bombs came down from above in what was to be Wallasey's eighth visit by the enemy.

This occurred in September 1940, but the resulting blazes were quickly extinguished by diligent and heroic firemen. There were no casualties. This image (left) depicts damage from a separate incident and shows what is left of Edith Davies' cycle and pram store, with the remnants of Stanley Browne's provision dealership alongside. Across the wrecked road, layers of rubble, together with several protruding pipes, are all that remain of the livelihoods that once prospered at these humble addresses.

Fifty-three-year-old Jung Gee (also known as Harry) and 8-year-old Eileen Noble both perished on 12 March 1941 at No. 149. Once again, their deaths brought home the harrowing truths surrounding the very real human losses of war.

THE VIEW OF 1940s destruction in Borough Road has been replaced by timber-clad buildings and semi-detached accommodation. Set back from this piece of road on a vast plot between Edith Street and Florence Street was once Winch House, a large property built by Henry Winch in the 1840s. He had made his money as a provision dealer specialising in tea, coffee and spices. Nearby stood another mansion, Hope House, in Borough Road. In the mid-Victorian era, Samuel Wright, the manager of the West India & Pacific Steam Navigation Company, lived in the property. It later passed into the hands of turtle purveyor George Hulse. This Chester-born businessman owned a shop in Liverpool's Dale Street, supplying restaurants across the region with rather more exotic ingredients popular at the time. The Irving Theatre was later built on the site, but after sixty years in the business it closed its doors in 1959. More recent demolition teams have got to work on this troubled thoroughfare after businesses here began to suffer as a result of the recession. In the 1980s, various empty properties were torn down to make way for new housing and further regeneration projects.

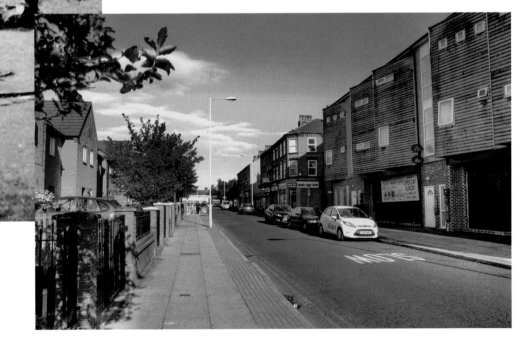

ST GEORGE'S CRESCENT AND LORD STREET

TWO CHARITABLE LADIES are seen here (right) serving up tea from an urn perched upon the back of a Ford convertible to a mass of thirsty bystanders. Such benevolent street scenes were common as mobile canteens were rolled out in their masses to bolster public moral across the nation. During the May Blitz, 25,000 gallons of tea were drunk and 2,000 gallons of Scouse stew was consumed across Merseyside alone. The obliteration of St George's Crescent is all too apparent as masses of rubble and annihilated buildings make up the miserable concrete landscape. Lord Street is seen to the left of the image with the gothic tower of Bunneys department store standing in the distance at the junction at Whitechapel and Paradise Street. Nearby, the tower of Diocesan Church House remains, with its recent repairs noticeably visible. This segment of the city gets its name from the long-gone St George's Church, several incarnations of which had stood on the site of the Victoria memorial between 1734 and 1899.

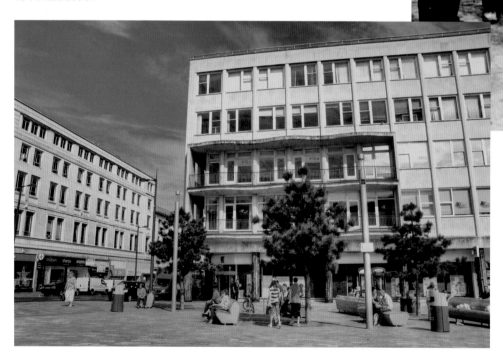

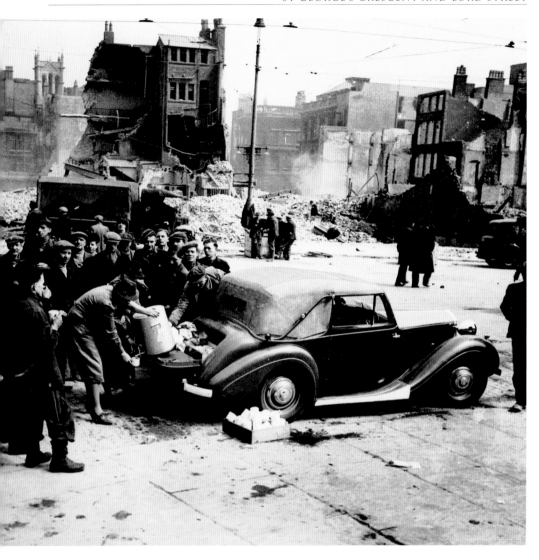

ST GEORGE'S CRESCENT has become a popular space for local employees to enjoy their lunch hour, or for city dwellers to just take a break in this afternoon suntrap. The large building in the foreground is Merchant's Court and is shared by several different companies. Lloyds TSB has a branch on the ground floor, and above is the offices of BPP, a financial training organisation. Gazing higher, the windows of the second floor are emblazoned with the initials of Pollard Thomas Edwards Architects (PTEa), which also operates from this location. Its designers have won many awards for their projects, with much of their celebrated projects located in the South East. However, PTEa have also worked on the regeneration of the Daneville estate in the Walton area of Liverpool, which was in dire need of improvement. Along with fellow design organisations, they helped 600 homes in the area reduce their carbon footprint and save money on household bills in a scheme which brought them widespread acclaim from industry experts and residents alike.

COLQUITT STREET

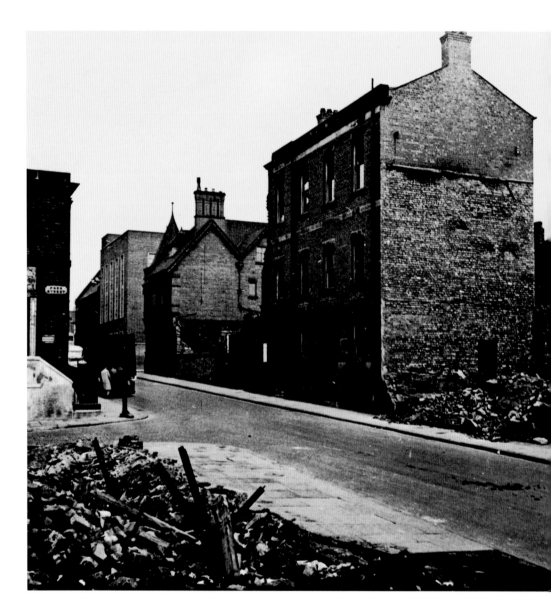

THIS THOROUGHFARE WAS named after John Colquitt, a customs collector and owner of a large plot of land in Hanover Street. His family made their fortune from plantations in America but these were later confiscated during the War of Independence. To the right of this view, the remains of the Fanny Calder School of Domestic Science stand. In 1875, Fanny Louisa Calder began teaching cookery classes for adults at St George's Hall, aiming to improve the diet and

lifestyle of the area's more humble residents. So successful was her scheme that it was developed into a fully functioning school, targeted towards young girls wishing to improve their abilities within the field of domestic science. Florence Nightingale was highly impressed and described Calder as 'Saint of the Laundry, Cooking and Health'. Several men can be seen loading a van outside the entrance to the Royal Institution. Based in Thomas Parr's converted mansion, the Royal Institution was established in 1814 to promote literature, science and the arts. It facilitated varied lectures given by respected speakers, and housed a number of important cultural works. The mass of rubble in the foreground is made up of Jason Carter's property (theatrical furnisher), and the shop of Jacob Finestone, a tailor.

COLQUITT STREET STILL exists but today looks a great deal different. The Domestic Science School was destroyed in the Blitz and in its place stands an apartment block, Elysian Fields. This was built in 2008 by the Liverpool-based Iliad Group and is valued at £25 million. It contains 105 individual flats and a car park. Iliad claim their role to be that of 'architectural revitalists' in a historic city of multiculturalism, arts and energy. They have created and refurbished numerous buildings across Liverpool, with fashionable and sought-after properties in Stanley Street, Leeds Street and Madison Square to name but a few. The Royal Institution building also stands, but is now hidden from view by the block of student flats which have arisen from the rubble. During the mid-twentieth century, the majority of the institution's collections were moved to more accessible galleries and museums based around the city, whilst other items were transferred to the University of Liverpool for educational purposes. The Royal Institution itself was formally dissolved in 1948. The building now operates as offices for the children's charity Barnardo's. The upper rooms are student pads for young academics of the nearby John Moores University lecture halls.

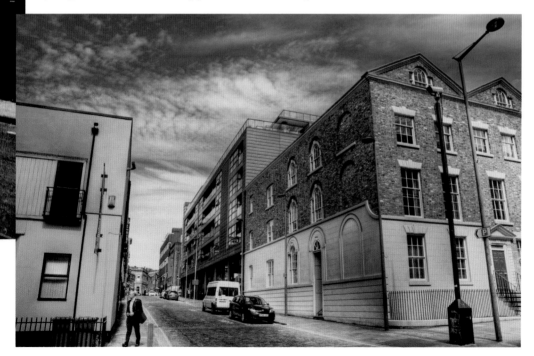

SCHOOL LANE

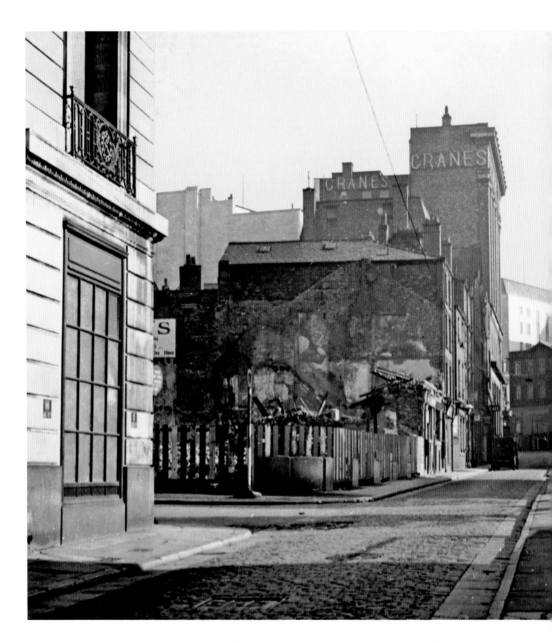

STANDING IN SCHOOL Lane in 1941, the photographer has captured the view towards Hanover Street with Church Alley to the left and the Bluecoat Chambers to the right. The Bluecoat was heavily damaged by enemy action; its concert hall, several adjoining rooms and a rear wing were destroyed. Construction originally began in 1716, funded by wealthy mariner Byran Blundell and Reverend

Robert Styth. It was their vision to create new premises for the boys of the Liverpool Bluecoat School, a charitable establishment set up to educate poor children of the area. Despite the damage of war, the Bluecoat remained intact and Liverpool managed to save its most ancient inner-city building. High up in the centre of the shot is perched the advertisements for Cranes & Sons, instrument sellers, whilst straight up the street stands a large warehouse, the home of a number of businesses including a café and restaurant, a gown manufacturer, a tobacconist and an advertising agency. These all survived the German air raids, but many other buildings in the locality, such as Magnet House, were left as nothing more than heaps of bricks and mortar.

SCHOOL LANE HAS become a useful passageway for pedestrians to reach the new shops of Peter's Lane and Paradise Street, but this route is no longer accessible to moving vehicles. The affordable Irish fashion retailer that is Primark opened its maze-like Liverpool store here in 2007. It manages to eclipse the firm's flagship London store by some 14,000sq.ft and employs a small army of 800 members of staff to run this five-floor outlet. The old Cranes & Sons property is hidden by summer foliage in this view, but the company has long ceased trading from this address and the building is now used as a bar and Chinese restaurant. The small Neptune Theatre, also housed in the old Cranes building, is soon to reopen as the Epstein Theatre. The Bluecoat was revived in the 1950s and used as a display and craft centre for many years. In 2008, it received heavy investment and became a showcase of creative talent of all kinds. It is now home to over thirty creative industries including artists, graphic designers, small arts organisations, craftspeople and retailers, all under one roof.

THE BOAR'S HEAD, BIRKENHEAD

THE BOAR'S HEAD Hotel leans precariously to one side after having fallen victim to a visit from the Germans. This pub stood at the corner of Eldon Street and Saint Anne Street and in the years leading to the war it had been run by landlord James Lucas. The war also brought damage to other properties in the neighbourhood, such as the family home of the Kells, who lived at No. 6 Eldon Street. William was the head of the household and he made a living as a slaughter man. On the afternoon of

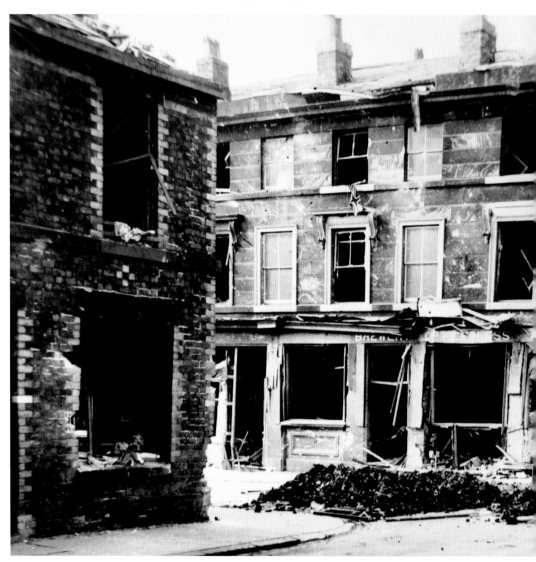

26 September 1940, many people on both sides of the Mersey looked to the waterfront to watch a barrage of defensive balloons rise up into the sky. Only two hours later, at 7.23 p.m., a formation of enemy Heinkels flew down the river, dodging bullets and balloon lines on a preliminary mission, but they were ultimately forced to fly up into the clouds. At 10.40 p.m., a second wave of bombers made their approach and released their ammunition relentlessly across the county. It was then that the Boar's Head suffered the wilful destruction shown in this picture, but it was also when Mabel Kell, wife of William, and their 8-year-old daughter Kathleen were killed outright. Their bodies are buried in Landican Cemetery alongside many of the other victims from the Second World War.

THIS QUARTER OF the town has been re-developed with many late twentieth-century houses; the aged, blitzed streets that once stood here have been altered and renamed. Eldon Street has become Birchwood Avenue and the old-fashioned grand properties of its past have all vanished. Just over a mile away, over in Bidston Avenue, stands The Avenue pub. This was built in 1957 and took its licence from The Canada Hotel and the Boar's Head, both of which were torn down for the benefit of public safety. The road in this scene (above) had previously continued all the way on to Market Street (so-called after the market that was set up in the early years of Birkenhead's history) but this is now cut off by the Camden Street car park. On the horizon is the circular rooftop of the Wirral probation centre, and further along is Hordan House in Price Street. This building contains various local government departments relating to work and pensions.

WOOD STREET

WHAT APPEAR TO be the remnants of C.W. Field's chemist can be seen here (right) at the corner of Wood Street and Concert Street in 1941. With entrepreneurial resilience, the owners relocated the business to Hunts Cross and erected an advisory sign near the site of their former address. Wood Street had been the location of choice for an array of merchants, and over the years the street has contained large numbers of storage warehouses and industrial office blocks. These included the Liverpool Electroplating Company and the print works of the popular newspaper the *Liverpool Daily Post* (seen in the distance). The *Daily Post* was founded in 1855 by Irishman Michael James Witty. He had also been Liverpool's first Chief Constable, and after running the force for eleven years, returned to his previous occupation as a journalist and embarked on a groundbreaking new project. He successfully advocated the abolition of the Stamp Act on newspapers (seen by many as a tax on knowledge) and, with his retirement funds, went on to found his own innovative and affordable paper. At a penny a copy, it was the first such penny paper in the country.

WOOD STREET TODAY appears as a rather quiet and unpopulated back avenue, but come nightfall, things are very different. Concert Square is

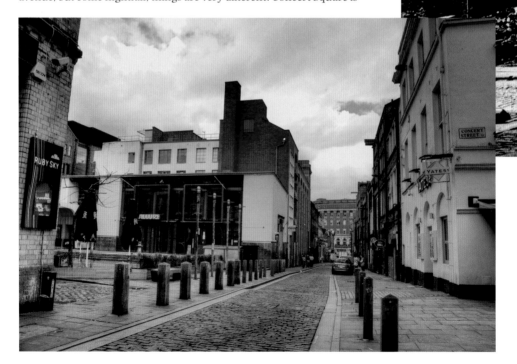

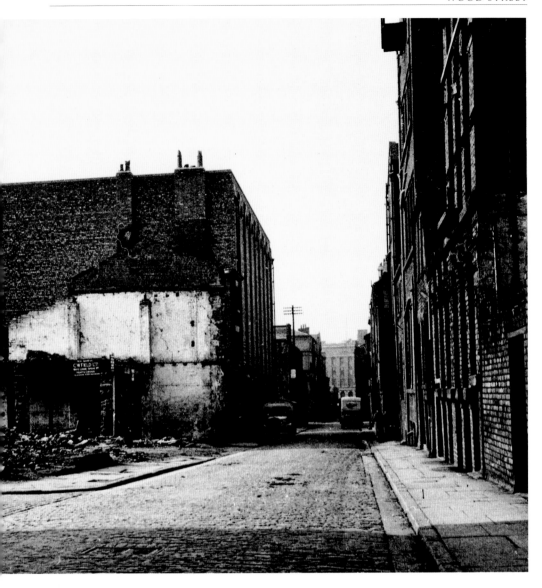

packed with bars such as Ruby Sky, Walkabout and Allure; it has even been described as the 'heartbeat of Liverpool's nightlife'. However, as with many big cities, crime has been a problem and this part of town has had its fair share. Cautious locals will often divert to the nearby Slater Street and Seel Street for a more relaxed experience, or make the ten-minute walk to Matthew Street for a change of scenery. In Wood Street, Mr Witty's old newspaper works has been transformed into one of the most established yet diverse clubs in Merseyside. The Krazy House takes up one half of the former printing premises and offers its guests a choice of three dance floors, each playing different music well into the early hours. The more sober of its patrons may well notice two small winged heads positioned above the club's entrance. These represent the *Mercury*, a newspaper based here since 1879. This merged with the *Daily Post* in 1904; the newsroom is now based in Old Hall Street.

SEEL STREET

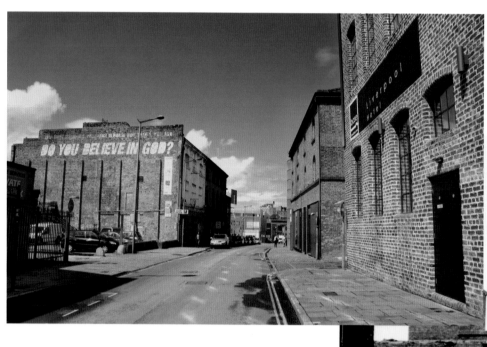

SEEL STREET HAS clearly suffered a sizable hardship, as one of
its buildings lies flattened at the roadside with a medley of bricks
and beams spilling out on to the pavement (right). This was the
North West business premises of Goodlass Wall & Co., colour and
varnish manufacturers since 1840. The firm also had a factory
based in London's Great Portland Street and were well known
suppliers to the region's shipbuilders. Sandbags can be seen
piled up against the walls of the adjoining property, in an effort
to afford extra protection against bomb blasts and shrapnel. The
sand inside was just a tiny percentage of the 150,000 tons taken
from Formby shore to defend the city's buildings. Across the way,
bathed in sunlight, is the firm of Duncan A.W. & Co. printers,
with a small tobacconist shop positioned a short distance away
on the corner of Concert Street. Seel Street itself owes its name
to Thomas Seel, a local landowner who once owned an extensive
house here in the Georgian era. In 1790, a thoroughfare was
required for the increased traffic flowing through the growing
maritime city, with the new route to Berry Street chosen to run
through the land used by Mr Seel as part of his own personal
garden.

THE BLITZED BUILDING was never restored and today a car park lies upon the earlier site of the ruins. Curiously, the wall has been painted with a question, 'Do you believe in God?' This was placed here as part of the Visible Virals programme in 2008, in a joint venture between the Liverpool Biennial team and the Liverpool Culture Company. This was in the run-up for the city's Capital of Culture year, with the aim to inspire people to muse over matters we wouldn't ordinarily consider. Other questions painted around the city include: 'Do you like your neighbours?' in Duke Street; 'Do you believe in love at first sight?' in London Road; and 'Do you want to die old and slowly or young and tragically?' in Fleet Street. Across the road is the Base2Stay Hotel, opened in 2010 after £14 million was spent transforming the building from its previous incarnation, the Seel House Press. It boasts over 100 rooms and is close to many of the city's most loved attractions and nightspots.

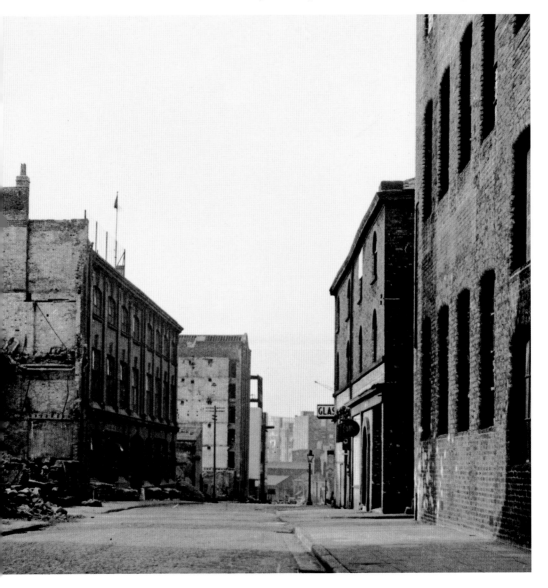

GRENVILLE
STREET SOUTH

IN THIS SCENE (right), utter havoc has rained down upon the
residential houses of Grenville Street South and Hardy Street. Their
contents lie piled about the pavements outside, as locals look on
underneath blown-out windows and disintegrated balconies. Further
along is the workshop of Joseph Critchley & Sons, makers of surgical
appliances, who appear to have escaped relatively unscathed. In the
background, the new Anglican cathedral, adorned with scaffolding,
is in mid-construction up on St James' Mount. It was the brainchild of
Francis James Chavasee, second Bishop of Liverpool, in the summer of
1901. Three years later, work began when the foundation stone was
laid by none other than King Edward VII. Work slowed down drastically
during the conflict and it was during these difficult times that the
cathedral had a very lucky escape. In the course of one nocturnal
Luftwaffe raid, a bomb penetrated the rooftop and fell directly into
the cathedral. Miraculously, it was deflected by an internal beam out
through a window, where it detonated its deadly contents without any
serious damage.

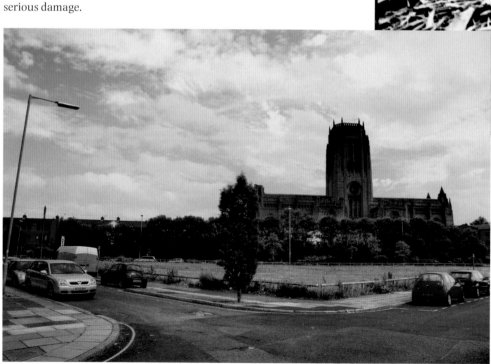

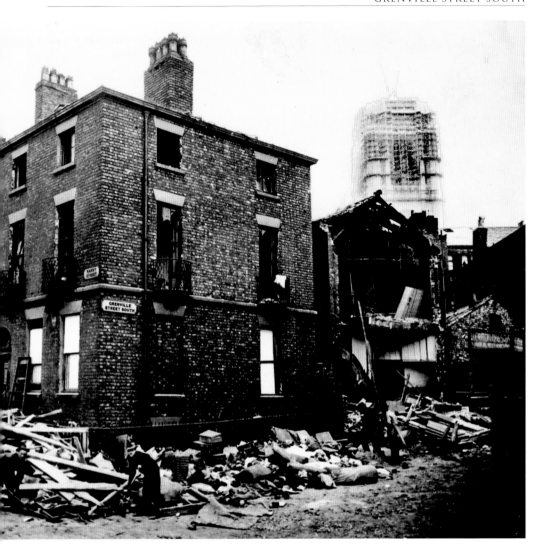

THE ROW OF houses that once existed on this verdant corner no longer remain. In fact, the majority of this area's original properties were lost during the war and have since been replaced by modern developments. This plot, however, remains untouched and lies in the shadow of the vast Anglican cathedral, which rises up from behind a distant tree line. It was finally completed in 1978, after three quarters of a century in the making, and can accommodate up to 3,000 worshipers. The cathedral also holds the astonishing record for housing both the heaviest and highest church bells in the world. Grenville Street South was once known as Leveson Street, but after a series of horrific murders here in 1849, the street name was changed in an effort to shed the memory of its brutal past. The victims of these awful atrocities were the heavily pregnant Ann Hinrichson, her two toddlers Henry and John, and a maid, Mary Parr. Their bodies are buried together in St James' Cemetery, which now falls within the grounds of the cathedral. Their killer was lodger John Wilson and he was sentenced to death at Kirkdale Gaol for his atrocious crimes .

LIME STREET

LIME STREET IN 1948. Post-war life goes on, but the enduring scars of the previous years are clear for all to see. The Palais-De-Luxe, seen in the centre, was one of a number of cinemas built to entertain the masses in the late nineteenth and early twentieth century. When war broke out on 3 September 1939, all cinemas and places of entertainment were closed on government instruction for fear of being easy targets for the expected hordes of overhead hostiles. Ten days later, after such numbers failed to materialise, theatres and cinemas were reopened and became particularly important additions in the fight against the enemy. Hearts and minds were crucial

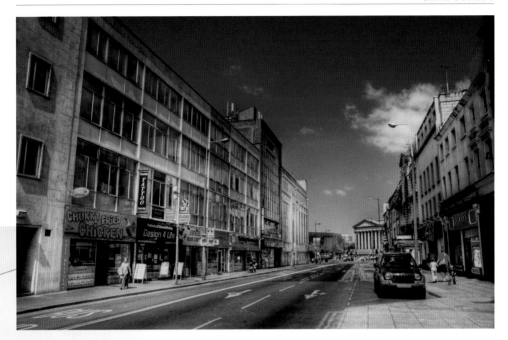

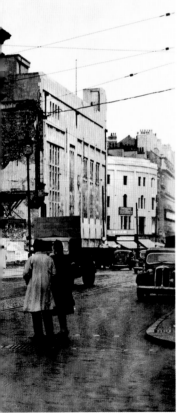

to the war effort and public morale had to be maintained. Cinemas also served as important information points and many government films were shown with updates from the front and advice on personal wellbeing. The side wall of the Palais-De-Luxe has been plastered with advertisements ranging from driving lessons and foot clinics to household cleaning products and concerts. Before the war, this empty segment of Lime Street was occupied by the shop of the tobacconist Albert Baker and a chemist shop, run by John Nelson.

A FAST-FOOD outlet, a tattoo parlour, an off-licence and a newsagent now occupy the Palais-De-Luxe's old spot on Lime Street, as well as the skills company Training Plus. The cinema suffered a fire in 1951, and with an eventual decline in numbers it closed its doors for the final time in 1959. The white building seen at the corner of Lime Street and Elliot Street is the listed shell of the Forum. Also known as the ABC, this was regarded as one of the area's most well-liked cinemas, but it too shut down in 1998. The early years of twenty-first century are proving better for the film industry. In 2009, UK cinema levels reached their peak, when 173.5 million visits were made to their local picture houses. Liverpool's main cinema, the Odeon, can now be found up a tall escalator in Liverpool One's Paradise Street. It has fourteen screens and a total capacity for 3,000 movie-goers. It opened in October 2008 after the closure of the city's London Road Odeon, which had operated from that location since 1934.

PREESONS ROW

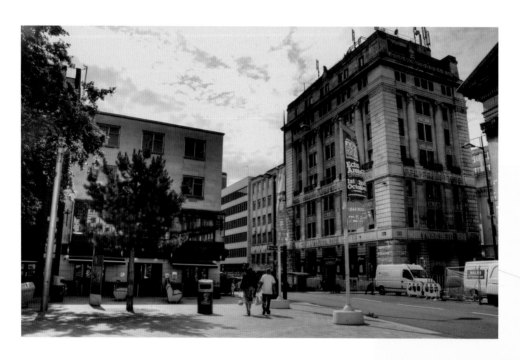

PREESONS ROW IS said to be named after Alderman Thomas Preeson, who built a series of properties here in the seventeenth century. Before that, Liverpool castle had stood near to this location with its defensive ditch running along the line Preesons Row would later be built upon. Bombing destroyed these aged properties, with losses including The Queen's Hotel, James Hall & Sons butcher's shop, and the Star Carbon Paper Company. In the background is the iconic Royal Liver building, headquarters of the insurance specialists the Royal Liver Group. The business was first established in 1850 as the Liverpool Liver Burial Society, which was set up to provide respectable internments for its members after death. During the war, this was the tallest structure in the city and as such, the authorities fully expected it to be hit. Incredibly, neither it nor any of its neighbours were harmed. The two Liver birds perched above, symbols of Liverpool, were designed by German sculptor Carl Bernard Bartels, in 1911. During the First World War, at the height of suspicion, Bartels was charged as a prisoner of war and forcibly repatriated to his home nation. He was sponsored to return to the UK several years later, when, among other occupations, he made artificial limbs for the maimed soldiers of the Second World War.

THE NATIONAL BANK building stands tall to the right of this scene (left), with what appears to be a collection of TV aerials perched on its rooftop. These are connected to the host of apartments now available to rent in the building's upper floors. The whole of Derby Square has recently undergone an important improvement scheme with the addition of new lighting, security, benching and added foliage to the area. The Queen Victoria monument (to the left of the photograph) was also cleaned and polished to reveal her former state of glory. The flags seen on the pavement are used to advertise the range of events held across the region all year round, including those at Merseyside's wonderful waterside arena, the Echo. Named after one of the area's local papers, the arena is the eleventh largest in the UK, holding 11,000 spectators. Its stage has seen such notable acts as Sir Tom Jones, Lady Gaga, Muse and Beyoncé, as well as hosting big events including X Factor auditions, the BBC's Sports Personality of the Year, and the 2008 MTV Music Awards.

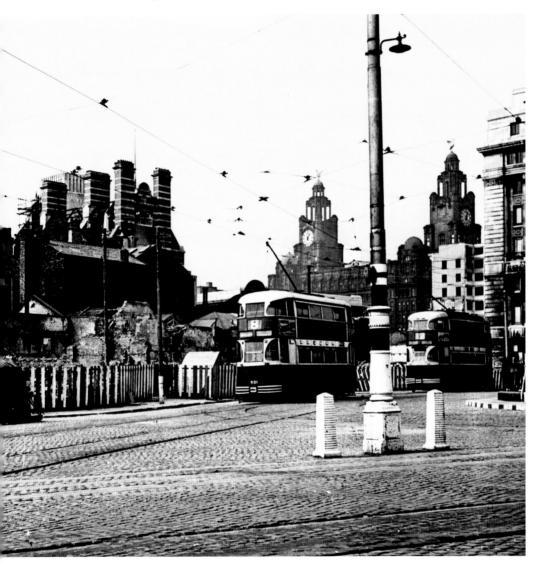

POULTON ROAD METHODIST CHURCH, WALLASEY

THE REMAINS OF the Seacombe Primitive Methodist Church are seen here in Poulton Road (right). The church's origins stretch back to the early Victorian era, when a local teenage convert named William Hughes began holding small prayer meetings with an assembly of fellow believers. Over time, the meetings grew to such popularity that a dedicated chapel was set up in Brighton Street. These meetings also went from strength to strength and by the 1930s, the church had moved to the corner of Northbrook Road into the purpose-built structure shown in this image. The ravages of the Blitz took its destructive toll and much of the building was destroyed. It was never repaired and the shell left behind deteriorated for the remainder of the war. The church was not the only loss in the attacks. As well as the numerous other properties that crumbled in the locality, several locals lost their lives in consequence of the much-feared air raids. At least seven are known to have died from the attacks of 1940–1 in Northbrook Road, with a further nine in

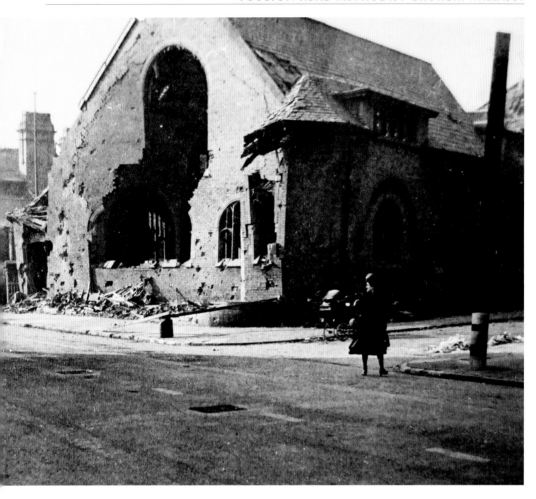

Poulton Road. This included 59-year-old Evan Williams, a member of the ARP, who was injured on 12 March 1941. Two days later, his body succumbed to the trauma and he passed away at Wallasey Cottage Hospital.

THE METHODIST CHURCH has gone and in its place is the playground of Somerville Primary School. This is one of twelve primary schools in Wallasey and has just over 450 pupils. There are a total of forty-four members of staff employed at the school, made up of teachers, teaching assistants and caterers. In addition to the National Curriculum, Somerville Primary offers its students various extra-curricular activities such as chess club, cookery club, the school choir, tag rugby and positions on the school magazine. The school's name dates back to Somerville House, a large mansion that once existed here. It had been built in the 1850s by James Finlay, a local merchant who made a fortune in the profitable tea industry. The house edged into decline after Somerville Elementary School was constructed on the present-day site of this school in the 1890s. The mansion was finally demolished in the twentieth century and the residential terraces of Mollington Road and Halville Road now cover its grounds.

ST GEORGE'S CRESCENT

ANOTHER VIEW OF St George's Crescent is seen here with the North John Street ventilation tower in the distance. This tower was built in 1934 to ventilate the long-awaited Queensway Tunnel. At just over two miles long, the tunnel connecting Birkenhead and Liverpool was seen as a truly marvellous example of engineering achievement and allowed a commute across Merseyside in only six and half minutes. At the time, it was the world's longest sub-aqueous tunnel; a title it held for twenty-four years. To the left of this vista is a branch of Barratt's shoe stores standing at

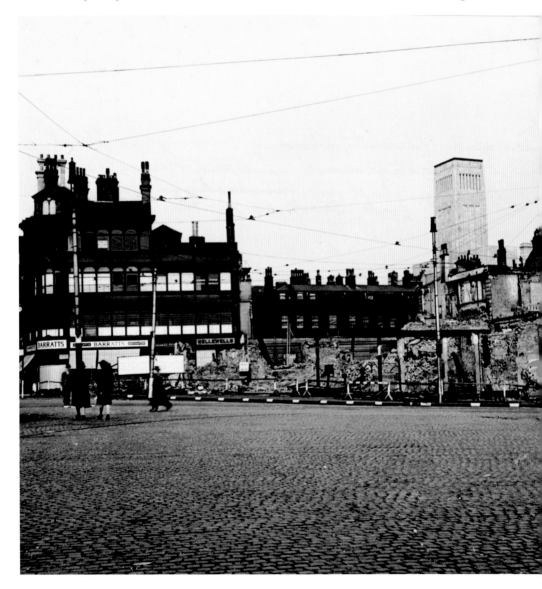

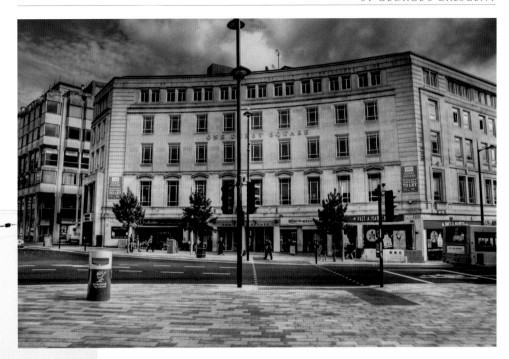

the corner of Castle Street, and next door is Hellewells & Co., manufacturers and exporters of Indian rubber. Harrington Street can be seen through the debris, as a number of properties in Lord Street have been ruined beyond repair. The crescent was developed in the early nineteenth century, when a handful of residential houses were removed and the area enhanced at great expense. A contemporary observation reports a figure of £170,000 worth of improvements were made in order to make this historic part of the city a most desirable and sought after business and residential location.

ONE DERBY SQUARE has risen like a phoenix from the piles of masonry that had been sent crashing down here in the 1940s. This arched business premises stretches into both Castle Street and Lord Street and features plentiful rooms across four storeys. Current occupiers include the Castle Street Coffee House, Challain's sandwich shop, Blankstone opticians and a Pret A Manger. To the left of this scene, there is a small commemorative plaque highlighting the vicinity's origins way back in the High Middle Ages (*c*. 1235). The giant ventilation tower is hidden from view but still helps pump out noxious fumes from the underground road tunnel beneath. By the 1960s, traffic in the tunnel was becoming increasingly congested, so it was decided that a sister tunnel, the Kingsway, should be constructed, linking the city with Wallasey. This opened in 1971 and still continues to serve commuters. Statistics show that an average of 35,000 people use the Queensway Tunnel on a daily basis, and recently it featured in the first instalment of the blockbuster *Harry Potter and the Deathly Hallows: Part I*.

STANLEY STREET

THE 200-YEAR-OLD Stanley Street is viewed here from Whitechapel in 1941. Hugo Lang's shop stands to the immediate left at No. 19. Established here ten years earlier, he specialised in fine art but also produced picture postcards portraying many scenic views from across Britain. Records show that Mr Lang had previously run a gallery in Bold Street in the 1890s, but by the time of this picture, that property was being run as the Kardomah Café. Further up the road protrudes a sign for Thomas Brackell's printing establishment, neighbour to Edwyn Crouch, a tobacconist

and the tea merchants T.R. Gee & Co. Across the way lies rubble from the gothic upper floors of Victoria Street's General Post Office, whilst to the immediate right we see a large brick building housing George Lunt & Sons bakery. Looking up past Matthew Street, the Korna Café stands at the junction of Victoria Street with provision dealers and numerous fruit merchants occupying the adjacent properties. After an agonising two years, the Nazi's reign of terror over Merseyside began to diminish as Hitler turned his attention to the Soviet Union. Three months after this photograph was taken, the Luftwaffe paid their final ever visit to Merseyside.

HUGO LANG'S PICTURE store has evolved into Wongs jewellery store. Wongs was established in Liverpool in 1979 with a shop originally based in the heart of 'Beatlesville' – Matthew Street. In their thirty-five years of trading, Wongs has established a fine reputation for intricate repairs and bespoke designs. Across the street stands the Met Quarter, and a well-located taxi rank is based outside. Other businesses based here include the Casa Italia restaurant, solicitors Yaffe Jackson Ostrin, Cybase web designers and the tailor Peter Harland. Halfway up the street is a striking sculpture by the 1950s pop idol Tommy Steel. His bronze of 'Eleanor Rigby' sits solemnly upon a stone bench and was installed in 1982. It is fittingly dedicated to 'all the lonely people' who come to join her. Across Victoria Street, Stanley Street continues, and it is this part of town that houses many of Merseyside's gay-friendly establishments. One such bar, the Lisbon, has an extraordinarily ornate Grade II listed ceiling. In 2011, the green light was given to officially recognise this area as the city's Gay Quarter, with aspirations for it to one day rival those famous districts in London and Manchester.

PARADISE STREET

THIS PHOTOGRAPH (RIGHT) was taken from King Street, looking out towards Liverpool's leading shopping destination, Lord Street. Hugh Toner's auction rooms are situated here after moving from an address in Redcross Street. Doubling as an estate agent, he had a second establishment in New Brighton and with his son, Herbert, ran the business that he had founded in 1898. Next door is a sign for the Dofsky brothers, Harry and Samuel, tailoring experts. Harry specialised in menswear whilst Samuel dealt with ladies' wear. Gazing up the street, several obliterated properties lie as piles of wreckage. These include the decorating firm Staunton & Sons, Evans the tailors and the office of Mr Isherwood, a manufacturing agent. At No. 51 stands the mercantile outfitter J. Baker & Co., who was only a few doors down from the oddly named pub, The Alligator. Breaking through the skyline is the clock tower of Municipal Building in Dale Street, and beneath is Wallis & Co. gown sellers and the consulting rooms of Cowan & Sons, ophthalmic opticians.

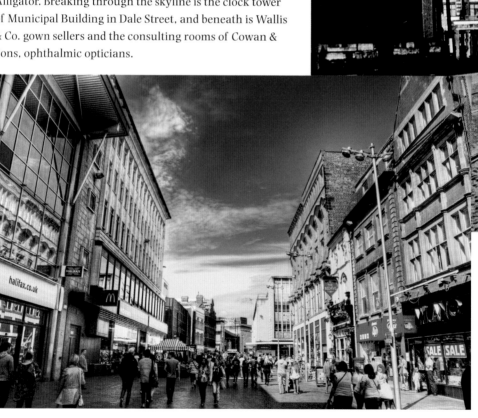

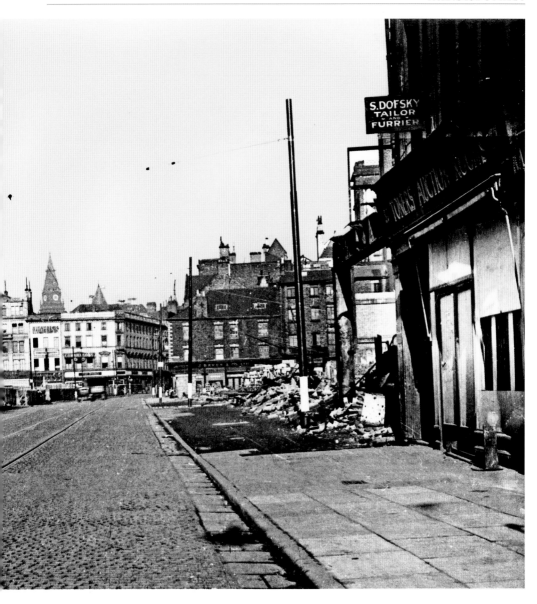

ONE OF THE most rejuvenated segments of Merseyside has to be Paradise Street. During the war, many central boulevards suffered abysmal damage, and post-war Merseyside's population went into the demographic decline that has persisted for decades. In 2004, explosives experts were hired to comb this area for any unexploded bombs left over from the carnage. This was in order for Lord Grosvenor's building work to begin, the first task being to remove a rather hideous old car park and relocate the bus interchanges to their present-day site. Previous to twenty-first century redevelopment, Paradise Street was very different, existing as a largely unremarkable thoroughfare. Many of the city's residents lived elsewhere with few retail choices on offer. Today, there are almost 25,000 people living in the city centre; a tenfold increase from only twenty years ago.

DRURY LANE

THIS SORRY SIGHT (right) shows the old properties on and around Drury Lane vanquished at the hands of an enemy bombing spree. Drury Lane was once the location of Liverpool's first official theatre in 1740. This was based inside the Old Ropery, which was near to the spot this shot was captured from. However, with the area's increasing population, plans for a new theatre were put into motion. The nameless street was then christened Drury Lane, after London's famous theatrical thoroughfare. In Water Street, the shelled-out skeleton of Colonial House can be found; just one of a number of buildings styled as a reminder to the city's global interests. Next door, New Zealand House stands just out of shot, whilst India Buildings exhibits a great deal of damage throughout its entire eight floors. Opposite lie the remnants of the Drury Buildings, which was the address of countless professions ranging from the hairdressing establishment of Eric Rigby in the basement, to the West African Drug Company high up on the seventh floor. All this changed on Saturday, 3 May 1941, when two visits by the Germans sent this building crashing to the ground.

DANGLING FROM ROPES at lofty heights is not part of most job descriptions, but this is all in a day's work for these window cleaners, bravely washing the grubby panes of India Buildings. The destruction of its internal rooms was quite severe but by 1953, the building had been restored to an immaculate state and opened for business once again. This image shows a small sandwich bar based within the ground floor, and up ahead is J. Marr & Co., electrical

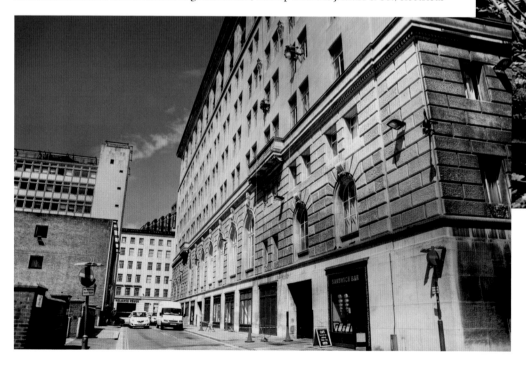

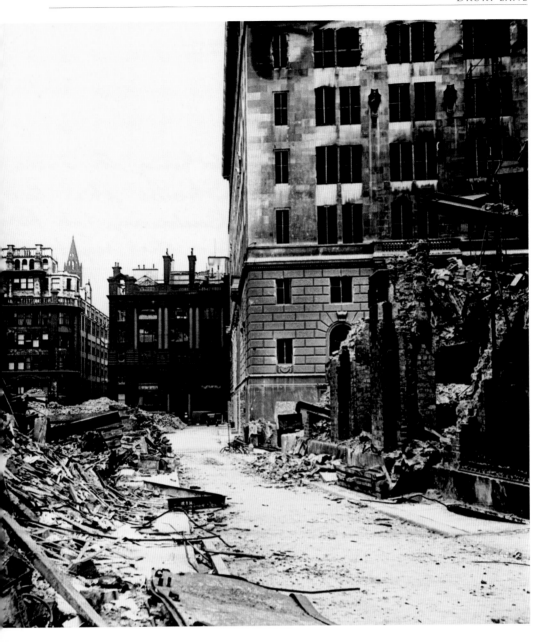

contractors, Hobs Reprographics, and Infinity beauty salon. In the distance is Reliance House, which had until lately served as the offices for local immigration services. In 2008, its doors were besieged by protesters rebelling against the government's planned introduction of the controversial ID card. This scheme was quickly scrapped by the new Coalition Government in their first act of official legislation two years later. The aged Drury Lane Theatre existed here until the late 1700s, when the new Theatre Royal opened in Williamson Square. It was there, in 1798, that the notable actor John Palmer died mid-recital, collapsing on stage during a performance of *The Stranger*.

BECKWITH STREET, BIRKENHEAD

THE MAIN ROAD through the densely populated neighbourhood of Beckwith Street is seen below pitted by craters, as residents and officials inspect the damage. In the background is St Anne's Church, which dates back to 1847. A series of concrete shelters had been constructed along this street in 1939, each having enough space for fifty people. In the run-up to war, these shelters predominantly benefited those lacking the space for their own private garden cover. The Beckwith Street shelters afforded those within sufficient protection from flying shrapnel and could be made gas-proof with specialist plugs if the dangerous situation worsened still. To the right of this image

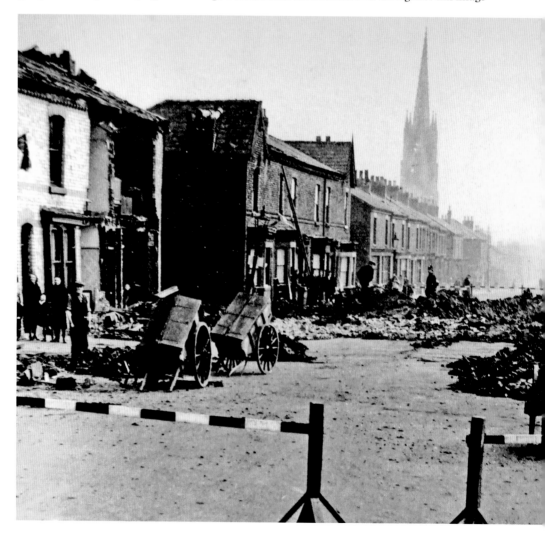

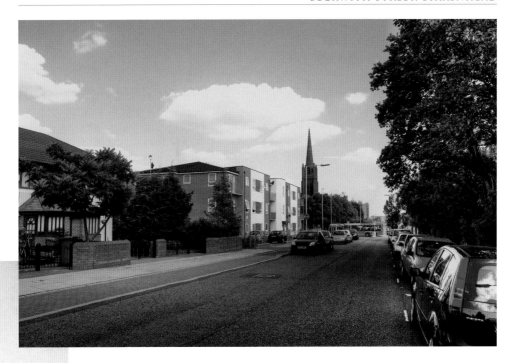

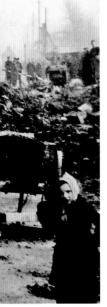

is the perimeter of Park Station, which suffered serious bomb damage – partly demolishing the booking hall and rendering its road bridge unusable. Despite this setback, the mainline was operating as soon as debris was cleared from the track. At least twelve people are known to have died in this street in 1940–1. These unfortunate victims added to an ever-increasing toll which saw 382 Birkenhead residents perish and another 606 seriously injured during the Second World War.

SIMPLE, TWENTIETH-CENTURY houses and contemporary flats now line Beckwith Street, in stark contrast to the multiple rows of terraced properties and shelters that formerly existed here. Numerous surrounding addresses that had witnessed the effects of the war – such as Roe Street, Wellesley Street and Stoke Street – have also vanished in the wake of suburban progress. These new flats, shown at the corner of Duke Street, were christened Beckwith Court, and built on the old site of The Pilot pub. The Cosmopolitan Housing group now runs the development, which features twenty-four apartments designed to meet specialist housing schemes. This is in order to help locals who are priced out of the property ladder to buy their own home. St Anne's Church underwent a series of alterations and improvements in 1991 and was renamed Christ the King. This parish is relatively new, after merging with the parishes of St Peter and St Mark. Its tower still features as a prominent landmark in this part of town, and the Birkenhead Priory Parish continue to meet there every Sunday for worship. Park Station has been totally reconstructed; during normal service trains to Liverpool operate every ten minutes and to New Brighton and West Kirby every fifteen minutes.

CHURCH STREET

THIS VIEW OF Church Street (right) was taken from a little
side street known as Clayton Lane. At one time the lane was
accessible and led to Clayton Square, from which it takes
its name. The man on the extreme right is about to pass the
stairway up to Mrs Lucy Sutherland, a specialist in electrolysis,
beneath which is the glass window of Broadbridge's opticians.
Across Parker Street is the magnificent Compton Hotel, which
was rebuilt in the 1860s after a fire destroyed its predecessor. It
was fortunate enough to survive the multitude of incendiary
bombs which wreaked havoc across Merseyside during this later
period. This cannot be said of Russells Limited, who occupied
the plot now left vacant at the barren corner of Church Alley.
Nearby is a branch of Burtons, founded by the Lithuanian-born
businessman Sir Montague Burton. During the war, his factories
produced a quarter of all the uniforms required by the British
army, as well as their de-mob suits upon leaving service. Master
tailor Hugo Boss was employed by the Nazis to produce their
swastika-clad uniforms and even used the forced labour of
prisoners of war to meet demand.

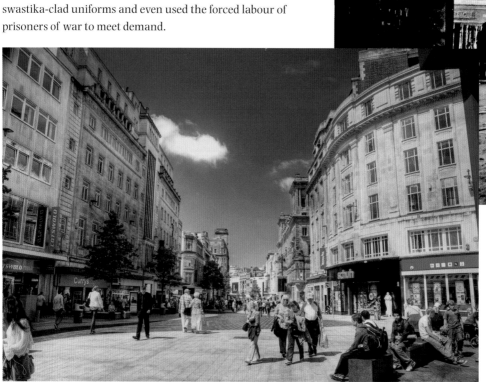

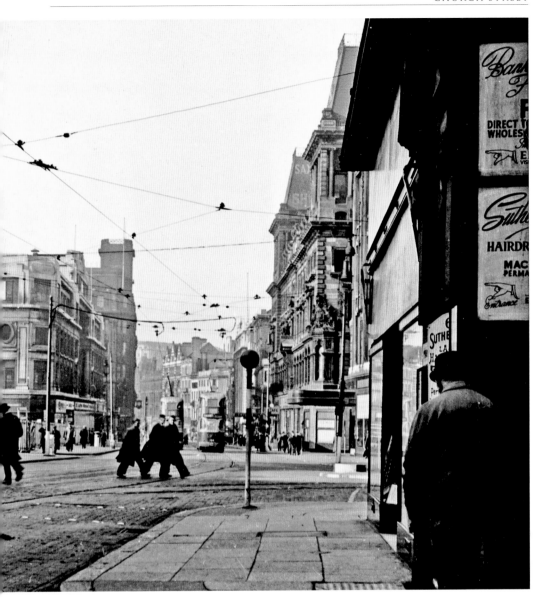

CHURCH STREET CAN be seen here (left) under the midday sun in 2011. Spinney House is to the left and was designed by the architects Robert Threadgold and Alfred Sherman. It was completed in 1955. It stands upon the previously empty plot, left behind from wartime bombing and was built as the new headquarters of the Littlewoods shopping empire. Today, Spinney House is home to various businesses and its nautical decorations include carved dolphins, tridents and seahorse pilasters. Nearby, Burtons continues to trade from the corner of Church Alley; it has now been in business for over a century. A short walk away is the Compton Hotel, which has recently undergone a thorough cleaning. Marks and Spencer now use the building for retail purposes. Compton House, as it was first known, was originally built to house just one retailer, making it one of the first ever department stores.

TITHEBARN STREET
AND VAUXHALL ROAD

TITHEBARN STREET GAINS its name from the tithe barn that stood here in the sixteenth century. Such barns were common across Europe at this time and were used to store an area's local tithes – a tenth of a farmer's produce as payment to the Church. This view from the 1940s (right) shows yet more evidence of the Blitz; it has demolished several buildings at this junction. William and Jason Jones' dining rooms are no more, and Mrs Ryan's shop, which was once at its side, has also gone. Other properties wiped out included Mr Shuttleworth's herbalist shop, the Woodman Inn, and Blumenow boot repairers. However, some properties remain standing, such as the City School of Commerce and its smaller neighbour the St Nicholas Church Institute (and its Penny Bank located within). With so much debris to manoeuvre and so many men fighting abroad, 9,000 workers from outside the city were tasked to assist locals in clearing through the rubble. To boost numbers within the emergency services, pensioned police officers were sworn back in as reserves and the Women's Auxiliary Police Corps was founded. By June 1943, there were over 7,000 female officers employed in assisting police forces nationwide.

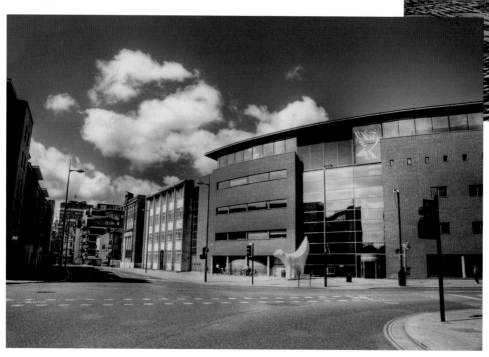

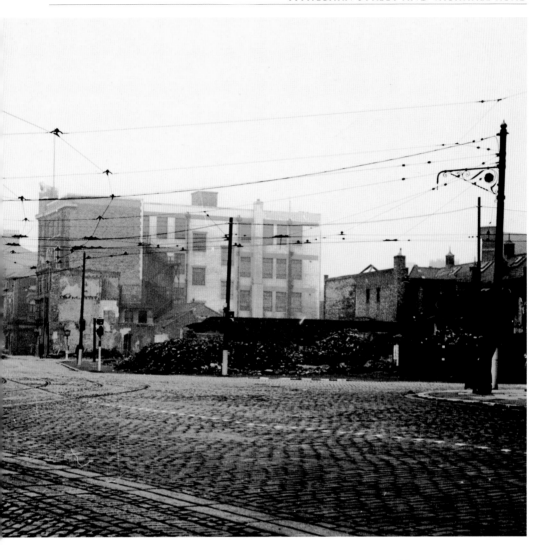

TODAY, THE VERY peculiar Super Lamb Banana is the main attraction of this part of town. It has become something of an eccentric symbol of Merseyside. The sculpture weighs in at a whopping 8 tons and stands at a height of 17ft. It was the design of Japanese artist Taro Chiezo, who created this yellow structure as an ironic take on the dangers of genetic engineering. Its form is derived from the area's dock history, as many quantities of lamb and banana passed through local ports in times gone by. As part of the 2008 Capital of Culture celebrations, 125 mini Super Lamb Bananas went on display across the whole of Merseyside, each painted with their own individual themes and designs. Many were later purchased by local organisations and can now be found in various parts of the city. The Avril Robarts Resource Centre is one of Liverpool John Moores' university buildings and has stood here since 1997. Over the road, the student accommodation, Victoria Hall, has 400 rooms, each divided into three and five-bedroom flats. At present, Liverpool John Moores is the twentieth most populated university in the UK, with 24,000 students in attendance.

BOLD STREET FROM
ST LUKE'S PLACE

THIS IMAGE SHOWS the neighbourhood at the top of Bold Street, taken from the intersection known as St Luke's Place. This area of town suffered overwhelming damage in the 1940s and many of its old buildings were burnt to the ground. A man can be seen examining a now empty part of the street; only months earlier, several properties had occupied this space. Hussey & Co. ladies' outfitters was gutted, as was the shop of the curtain specialist Owen Hawker. Further along was the Almadene

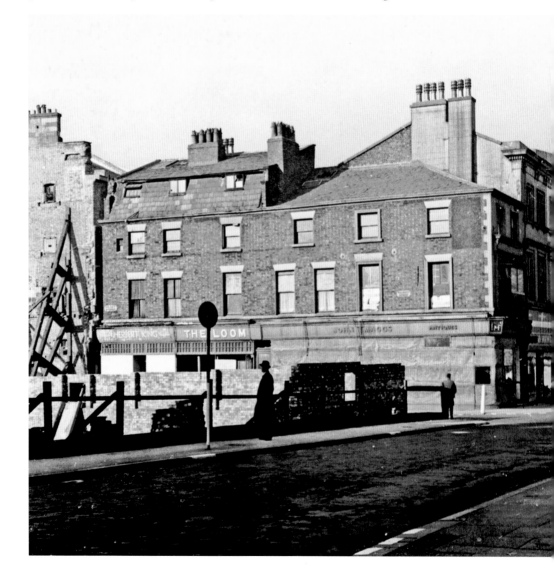

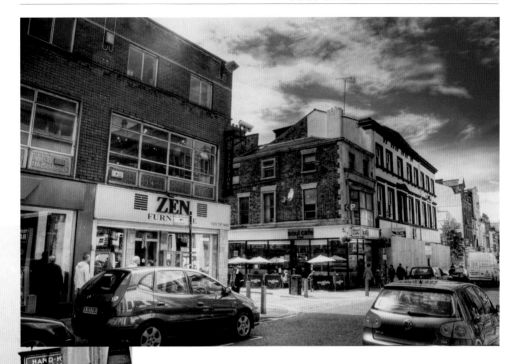

Studios, which sold an assortment of arts and crafts materials. This too met a fiery end. The staff there shared the spacious property with the photographer Leonard Carl, beer engine makers Gaskell & Chambers, the dressmaker Hilda Woods and a branch of the costumers Marshall & Snelgrove. It appears that one half of Colquitt Street at least has escaped relatively unharmed. The premises of antique dealer John Maggs, his neighbour at The Loom and the property of Herbert King seem to have suffered only superficial damage to their ground floors, with the glass having been completely blown out from their frames.

A COMPARABLE VIEW in modern times shows how this district has progressed from those dark days of conflict. The ex-antique seller has become the Soul Café, adding to the choice of eateries on offer in Bold Street and the surrounding locality. This is very different to its pre-war use, which saw the building occupied by no less than six separate proprietors. Behind the wooden hoardings is a project aiming to transform the rooms of Nos 110 to 112 into flats. At the time of the previous image this property had been in the hands of J. Blake & Co. The company had set up as carriage builders in 1871, and over the years became a trusted motor car company. Between 1908 and 1920, Blake's vehicles were responsible for transporting the Royal Mail all over Merseyside. Across Colquitt Street is the Zen Furniture outlet, which has traded here for over a decade.

MALLABY STREET, BIRKENHEAD

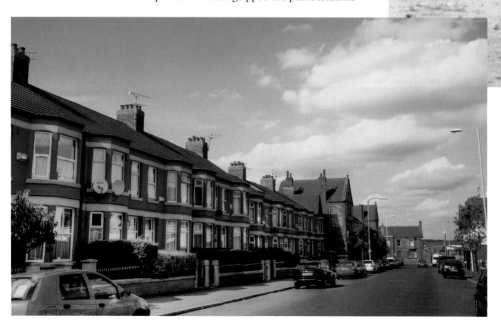

THESE ROWS OF terraced houses have been left in a critical condition after a raid in 1941. One fatality here was 66-year-old Sarah Robinson from No. 47. Despite her age she was a member of the Women's Voluntary Service. Sadly, she would never again see a return to the peacetime she worked so diligently towards. In the centre of the image, several buses – some overturned – were caught in middle of the overhead assault. Up ahead is the Laird Street bus depot and it was here that a handful of its night staff took refuge in a shelter. Seven men were killed and many buses obliterated when a fatal fleet of land mines were blown into the vicinity. Government advice for these situations was clear: 'When you hear the warning, take cover at once. Most injuries are caused by flying fragments of debris. Stay under cover until you hear the sirens sounding continuously for two minutes on the same note. This is the signal raiders have passed.' This advice failed to help all those who perished and their heartbroken relatives, who would have no choice but to live on with the nightmarish memories of war.

THIS VIEW SHOWS Mallaby Street today, restored to this serene residential setting. Situated near to Birkenhead's historic 90-hectare parkland, little evidence remains of the sheer panic that once gripped the past residents

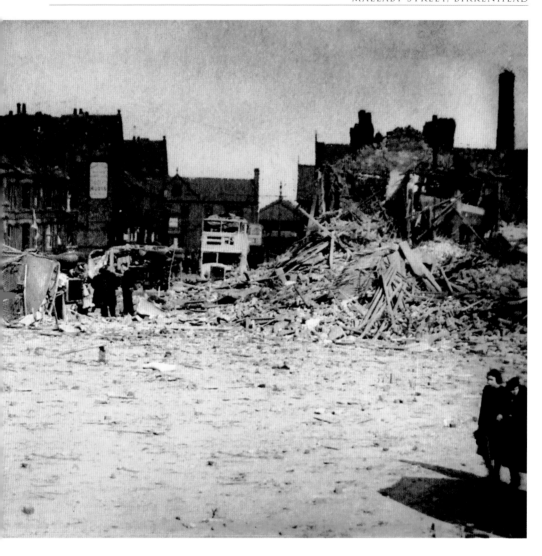

here. The bus depot continues to operate in Laird Street and is under the ownership of the transport giant Arriva, which operates in over ten countries. To boost relations in the run-up to Liverpool's 2008 Capital of Culture celebrations, the depot was chosen to become a part-time learning base for drivers to get to grips with the Spanish language. Classes were taught by tutors from the West Cheshire College, who have campuses at Chester and Ellesmere Port. In 2007, a section of the nearby park was dug up and out came the mangled wreckage of a wartime spitfire. Sixty-five years earlier, a plane piloted by Sergeant Goudie of the Royal Canadian Air Force began to experience engine problems whilst flying over Liverpool. The pilot bailed out and landed on top of the city's maternity hospital roof, leaving the aircraft to descend and ultimately crash into Birkenhead park. The Rolls-Royce Merlin engine, cockpit instrumentation, part of the pilot's seat and the remains of Sergeant Goudie's sunglasses have all been recovered and are now on display at New Brighton's Fort Perch Rock museum.

CLARENCE STREET

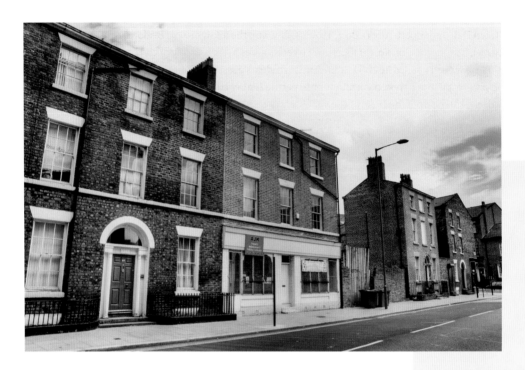

THE YEAR IS 1942 and here (right), No. 29 Clarence Street has collapsed, exposing a wretched scene of devastation. Several onlookers have stopped to inspect the conditions, and with them a number of small children. Over the course of the war, approximately 130,000 individuals were evacuated from Merseyside – many of them youngsters. When the war began, arrangements were made for parents to send their family to the apparent safety of the countryside, with North Wales and parts of Cheshire serving as popular local destinations. The more fearful of parents chose to send their children abroad to Canada, South Africa and even as far away as Australia for safety. Chilling fears had been fuelled across the nation by early government warnings and media notices of impending doom. In total, 1.5 million left the built-up cities of Britain for the relative safety of more rural havens. However, when German bombers failed to arrive at the time military experts had predicted, many children were brought home early, only to be met by the unmistakable sound of air-raid sirens crying out across their hometowns, and the sheer desolation that was sure to follow.

A SMALL BUT haunting gap still remains at the site of this Victorian terrace over seventy years since it was demolished. A building, currently unoccupied,

has been constructed over part of this once decimated address, and had previously been under the ownership of A.J.K. Property Maintenance. The two houses to the right of this view are early nineteenth century and are both Grade II listed. There are over 2,500 listed buildings in Liverpool but only twenty-seven of them meet the coveted Grade I status; these include the magnificent Town Hall, the superb Albert Dock Traffic Office and the infamous old Bridewell, just off Duke Street. The location of No. 29 Clarence Street now lies in the shadow of the Liverpool Community College, which opened in 2001, allowing its students access to a range of courses, enabling them to progress in their chosen vocations or to peruse higher education opportunities. The street itself takes its name from the Duke of Clarence, who visited the city in 1790. He was a favourite of many Liverpudlian merchants for his support of the colonial slave trade, which had paid for many of the city's improvements.

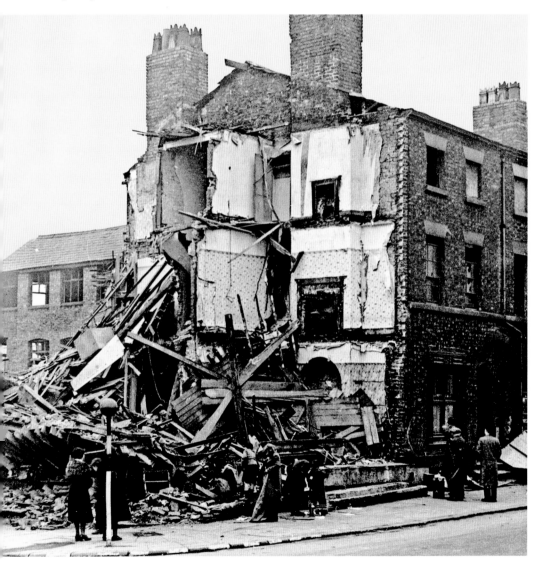

GREAT CHARLOTTE STREET

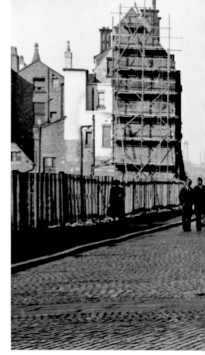

STANDING BENEATH LEWIS'S blitzed department store,
this photographer has captured a somewhat barren view of
Great Charlotte Street as it appeared at the height of the war.
A shadowy, flat-capped figure walks alongside the empty
shell of Blacklers, which stood here since the early years of
the twentieth century. It was founded by Messrs Blackler and
Wallis, and in its day was Liverpool's biggest store, employing
around 1,000 members of staff. Its once beautiful façade was
designed by Birkenhead-born Walter Aubrey Thomas, who also
designed Hanover House, Tower Buildings and even the iconic
Royal Liver Building, as well as numerous other impressive
creations across Merseyside. With Blacklers headquarters
out of action, the management began to open up a fleet of
temporary branches. Thirteen were established in Bold Street
with another in nearby Church Street. The basement of the
main building, however, did have some use and was regularly
flooded to provide much needed water to the brave fire-fighters
who risked their lives on a daily basis, tackling the multitude of
infernos that sprang up in all parts of the city.

BLACKLERS RETURNED TO its Great Charlotte Street address in the 1950s, from where it traded right up until its closure in 1988. Its demise was a sad day for Merseyside. Generations of locals had grown up with the store and many had fond memories of working as part of the Blacklers team. Nowadays, several companies share the building, including several bars, a bank, Pizza Hut, KFC and a walk-in health centre. There is also a large Wetherspoons pub which has been christened the Richard John Blackler, in honour of the site's important social history. There are currently over 800 such pubs in the UK, with more than twenty in Merseyside alone. The tall black construction at the end of the street is the home of Holiday Inn Hotel, sitting above St John's Market. Reflected in the upper-floor windows of McDonalds is St John's Beacon, built in 1969 and based in nearby Clayton Square. Standing at 452ft, it is currently the second tallest structure in the area and is home to one of the North West's most popular broadcasters, Radio City.

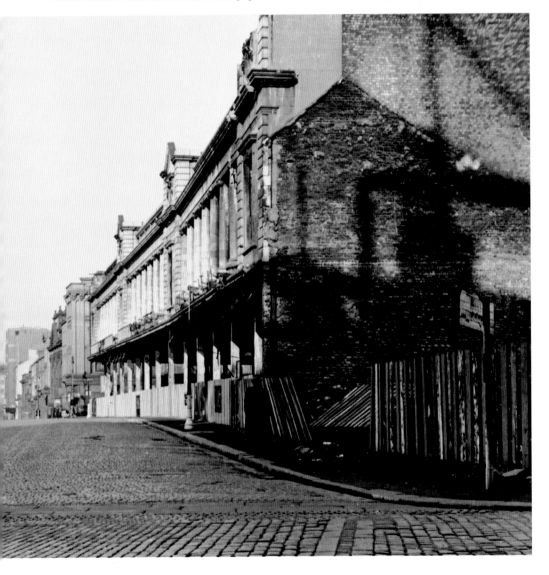

FENWICK STREET

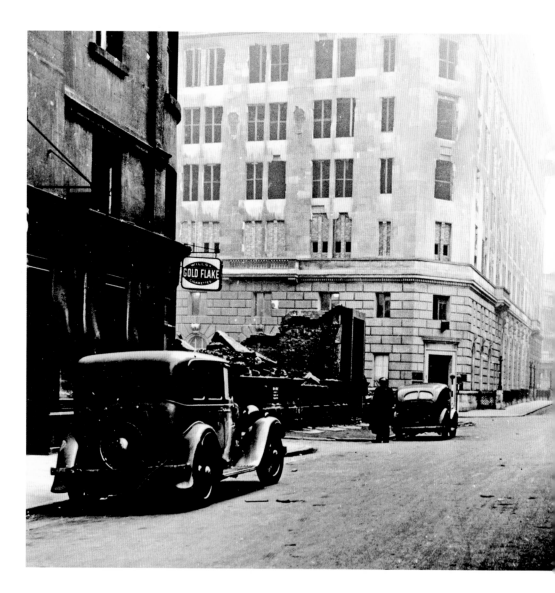

FENWICK STREET (which has in the past been referred to as Phenwyck Street and even Phoenix Street) was laid out in the seventeenth century by Sir Edward Moore, in honour of his first wife Dorothy Fenwick. It is seen here lined with a number of motor vehicles parked up at the roadside beside the remnants of once immaculate office blocks. The Corn Exchange previously stood to the left of this view. Founded in 1807 at a cost of £10,000, it was the first of its type in the country and served as a formal business location for traders and merchants for decades. It is said that on turning up for work and finding that their offices no longer existed, members simply conducted their

business out on the pavement and inside local coffee houses until a suitable replacement site could be found. Ahead is the rear of India Buildings. All its windows have been blown out and its multiple floors are unoccupied. Its construction required the removal of a small lane, known as Chorley Street, which used to stand here. Fenwick Street, Water Street and Drury Lane were also widened considerably to accommodate this innovative 1920s construction.

THE DOOR AT the rear corner of India Buildings leads into a convenient post office known as the Corn Exchange branch. The Corn Exchange itself stands a stone's throw away and is now a desirable office location with eleven modern floors on offer to potential tenants. The Noble House bar and restaurant has opened up in a former bank building, founded by the merchant Arthur Heywood in the late eighteenth century. Today's owners have worked towards fusing the discretion of a 1920s speakeasy with the style of a downtown Manhattan restaurant, achieving exciting results. The bistro's head-height windows can be seen by all who pass by this ancient establishment, which has been a gastronomic hit with the local community. Up ahead is Merseyside's tallest building, which can be spotted reaching 459ft into the sky. This is the West Tower, which features an amazing forty storeys, making it the eighteenth tallest skyscraper in the country. The thirty-fourth floor is home to Britain's highest restaurant, The Panoramic. The rooms in here are fitted out with floor-to-ceiling windows offering diners glorious views of the city, the River Mersey and the Wirral Peninsula.

PUBLIC ASSISTANCE COMMITTEE, BIRKENHEAD

THE PUBLIC ASSISTANCE Committee (PAC), shown here in wartime Wirral, was established after the Board of Guardians (itself based upon a system dating back to Tudor times) was abolished in 1930. The PAC inherited its predecessor's responsibilities and was charged with administering financial relief to the poor and unfortunate members of Birkenhead society. Staff moved to this gothic building in the early years of the twentieth century, after previously working from an address in Hampton Street. The building appears to have sustained a degree of shrapnel damage, which has made its

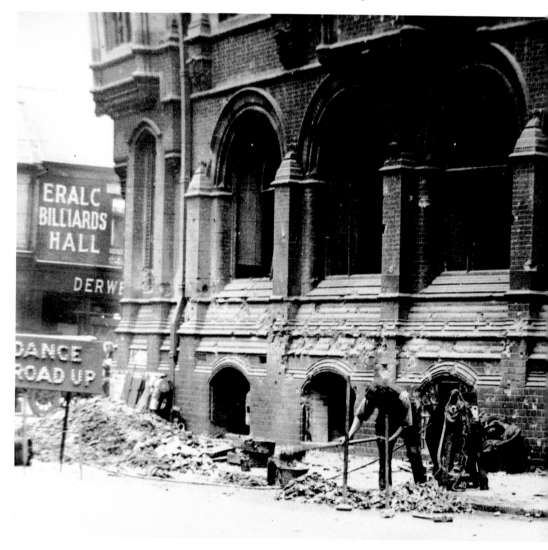

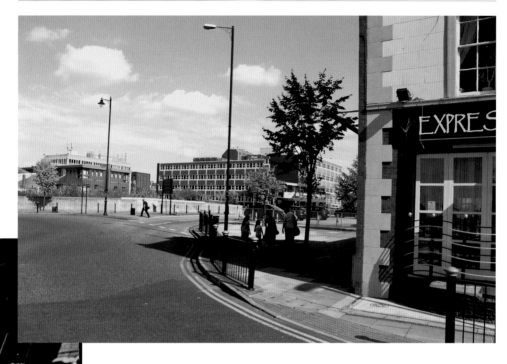

mark upon the walls and pavement, and its windowpanes have been destroyed. The building has also lost a distinctive baroque cupola that once existed above its eastern portion. A flat-capped man is seen working outside at the roadside with his bicycle resting against a nearby bench. Over in Conway Street is a sign for the ERALC Billiards Hall. It was founded by Edward Arthur Clare in 1912, who supplied billiard tables to at least eight clubs in the Merseyside area at this time. Next door is Derwent House, which supplied a variety of home furnishings across the district.

THE PUBLIC ASSISTANCE Committee premises continued to be used as council offices in the years following the war, but in 1967 the beautiful structure was pulled down and much of this part of Birkenhead was simply flattened. This was to make way for the Conway Street flyover, which, according to town planners, would be the best solution to the traffic problems besieging the tunnel approach roads. When the Wallasey Tunnel was added to Merseyside's system of infrastructure in the 1970s, the new viaduct road became obsolete and was itself demolished in the 1990s. This was another act of poor civic foresight and some of the town's oldest buildings were lost forever. This image shows one of the roads to the Queensway Tunnel as it merges onto the streets of Conway and Argyle. Up ahead is Haymarket Court in Hinson Street. This had until recently been the headquarters of the local paper, the *Wirral Globe*, but they have since moved across the water to Old Hall Street. The large grey building is St Marks House, which is home to a number of the borough's legal services including the Child Support Agency and the Crown Prosecution Service.

No. 25 Bold Street

THIS UNUSUAL VIEW (right) depicts a former shop in Bold Street, giving a rare insight into the heart of a blitzed-out property. The interior has been totally destroyed, with beams exposed, windows destroyed and even one half of the top floor completely missing, leaving this once prime retail location nothing more than a painful reminder of the cost of the conflict. This had previously been the store of W. Litherland & Co., whose name remains imprinted on the wall with a haunting yet wasted sense of resilience. Litherlands were sellers of high-class glass, china and earthenware but all these lavish commodities were reduced to worthless ashes and charred and blackened fragments. It had stood in between a branch of the Singer Sewing Machine Company, founded in 1851, and Van Gruisen & Son, a respected firm of musical instrument agents. During the Second World War, the British government approached Singer with the possibility of using their sewing needles as darts in the development of a new poisonous cluster bomb. However, the plan was scrapped in 1945 because the darts were considered to be a highly uneconomical weapon.

BUSINESS SEEMS TO be booming in this present-day scene. The tea shop Brew is one of the more recent additions to Bold Street, having opened here in 2009. To the right is the clothes shop Bench, which was first founded in Manchester in 1989. Alongside is the 1950s-themed diner Rockerfellas. Merseyside is affectionately remembered by many US servicemen who were stationed at bases around areas such as Aintree and Haydock. Down at the pier head there is a plaque that was installed by the 15th Port Unit of the United States army in 1944. It commemorates the thousands of US troops who passed through the district as part of the American war effort against Germany.

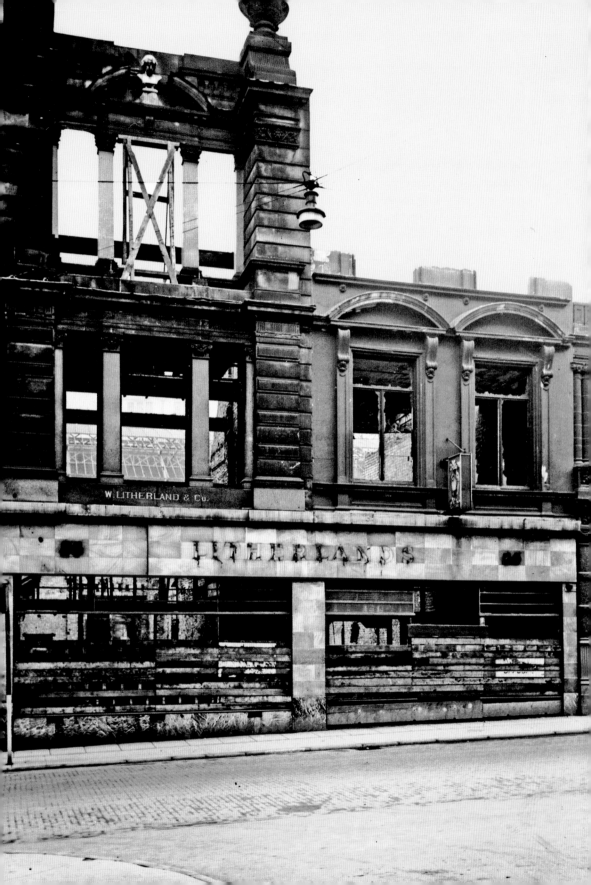

WOODCHURCH ROAD SCHOOL, BIRKENHEAD

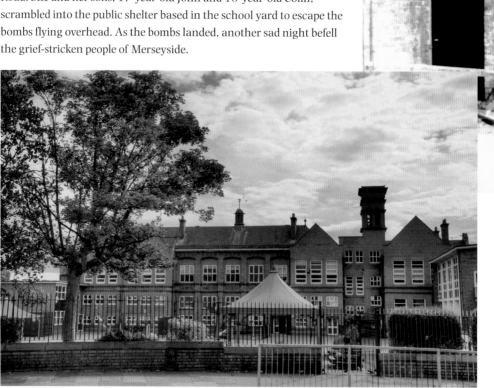

THE EMPTY SHELL of Woodchurch Road School (right) stands desolate for all to see. Gone are the wooden tables, the text books and even the pupils, whose lives were thrown into turmoil. The school had stood on this site since 1904, and before the war had taught approximately 600 of Wirral's youngsters. In the foreground, a group of people, probably including some of its youthful students, are inspecting the remains of a damaged bomb shelter. This had failed in its role to offer adequate safety to horrified locals during one raid in May 1941. During the night of 2 May, the school came under attack and eight people perished when the shelter collapsed down on top of them. Victims included Dora Bristow, wife of George Bristow, who lived at No. 145 Woodchurch Road. She and her sons, 17-year-old John and 10-year-old Colin, scrambled into the public shelter based in the school yard to escape the bombs flying overhead. As the bombs landed, another sad night befell the grief-stricken people of Merseyside.

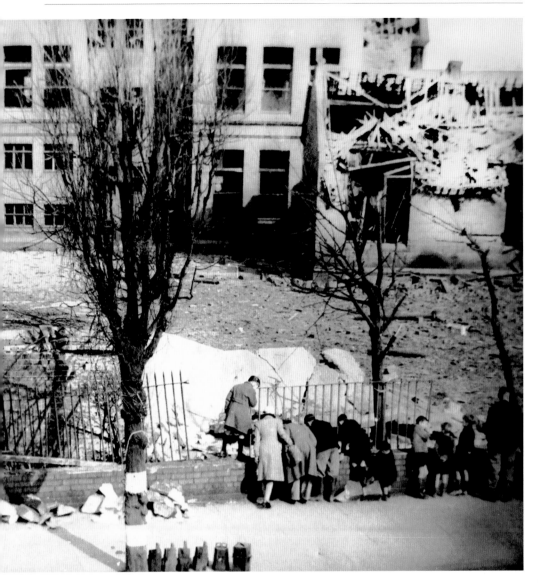

THE SCHOOL WAS repaired and is still in use today, with approximately 450 pupils on the registers. It is used solely as a primary school, with infant classes taking place on the ground floor and a mezzanine floor supporting the school library and kitchen. The upper storey is used to teach the older students, and there are also two halls where PE, drama and music lessons are taught. There is little evidence of the scars that the Nazis inflicted upon this building, except for the loss of an elevated tower that once featured on the school rooftop. This crashed down, along with tiles and windowpanes, when raiders flew over the school and released their dreadful cargo. The remains of the shelter have been cleared away and now the yard is used as an 'active playground', designed to educate children in the benefits an active lifestyle and personal fitness.

THE STRAND

THIS SOMEWHAT CRAMPED part of the Strand (right) has evidently suffered substantial damage, as piles of bricks and masses of materials are seen at every corner. A warning sign has been placed advising the public about the very real dangers of falling masonry. To the left stands the gigantic Wellington Buildings. With ten floors, it housed many businesses and organisations such as the Ministry of Labour, the Guatemala consulate, the electric cleaners Hoover Limited and a china clay merchant by the name of Ernest James. Across Brunswick Street, a vast pile of bricks is all that is left of the family business Steinman & Co. (shipping agents) and the firm Liverpool Warehousing Company. In the distance, the historic Albion House has had its gable damaged and its roof left widely exposed to the elements. It had been the headquarters of the famous White Star Line. When its ship the *Titanic* met with tragedy, many came to these doors to hear the official death toll on the morning of 15 April 1912.

A FUTURISTIC, GLASS cuboid high on the horizon can be seen on Mann Island, which, along with its sharp-shaped sisters nearby, has attracted some controversy. One critic raged that its approval was 'the biggest risk to Liverpool's skyline since Goering sent the Luftwaffe over in 1943', and there is a real degree of uncertainty over how well these structures will harmonise on this important World Heritage site. Mann Island was originally formed in the eighteenth century as part of the lucrative dock system. It may have originally been named after John Mann, a local dealer in oil and stone who died in 1784, and at that time was only connected to the area around James Street by a thin strip of land. The island ceased to be when George's Dock was filled in for the construction

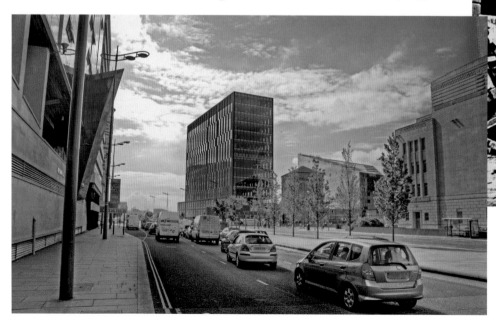

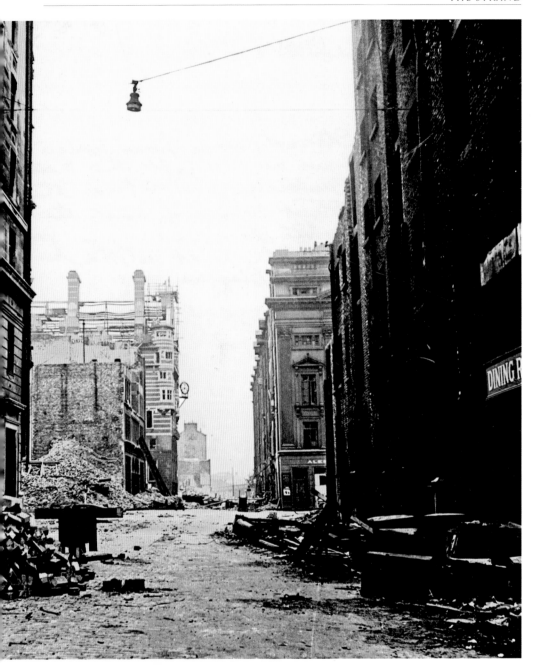

of what we now know as the Three Graces. The new designs feature both residential and commercial spaces, with Merseytravel recently signing a thirty-year lease along with the German bank CommerzRea. Despite initial concerns, there is no doubt that the developments have added a touch of modernity to this iconic area and will hopefully, one day, become as cherished as the neighbouring Three Graces.

Other titles published by The History Press

Wirral Then & Now
DANIEL K. LONGMAN, COLOUR PHOTOGRAPHY BY BARNEY FINLAYSON

Wirral Then & Now invites you to explore the peninsula's rich heritage in this fascinating pictorial compilation, contrasting forty-five archive images alongside stunning, full-colour modern photographs. Step back in time and compare yesterday's sleepy rural landscapes with today's busy townscapes. Visit the high streets of old and contrast them with modern bustling shopping districts, and witness the people of the past juxtaposed against their twenty-first-century descendents.

978 0 7524 6079 6

Liverpool Then & Now
DANIEL K. LONGMAN

Contrasting forty-five archive images with full-colour modern photographs, *Liverpool Then & Now* compares the fashionable man about town to his modern counterparts, and workers of yesteryear with today's trades-people. Along with some famous landmarks and little-known street scenes, this is a wide-ranging look at the city's colourful history. As well as delighting tourists, it will provide present occupants with a glimpse of how the city used to be, in addition to awakening nostalgic memories for those who used to live or work here.

978 0 7524 5740 6

Criminal Wirral II
DANIEL K. LONGMAN

This fascinating new volume is a follow-up to Daniel K. Longman's first book *Criminal Wirral*; an intriguing and entertaining collection of some of the strangest, most despicable and comical crimes that took place on the Wirral peninsula throughout the Victorian era and the early twentieth century. Read on and uncover the grisly facts of what once lay floating in Birkenhead Park pond, a gruesome suicide on board a Woodside-bound locomotive, and the farcical actions of a drunken butler at the stately Thurstaston Hall.

978 0 7524 5007 0

Criminal Liverpool
DANIEL K. LONGMAN

Criminal Liverpool is an entertaining and informative round-up of some of the strangest, most bloodthirsty, appalling and humorous crimes that took place in and around Liverpool from the Victorian era up to the mid-twentieth century. Daniel K. Longman uncovers many cases that have been long forgotten in this readable text. With fascinating illustrations, this book will appeal to everyone who has an interest in the darker side of the city's history.

978 0 7509 4749 7

Visit our website and discover thousands of other History Press books.
www.thehistorypress.co.uk